CHURCHES OF
SOUTHERN
YORKSHIRE

DAVID PAUL

AMBERLEY

Acknowledgements

I would like to thank many people who have assisted me in collecting and collating information with regard to the historic churches recorded in this text. I especially wish to record my thanks to many librarians across the county who gave me invaluable assistance and advice. Similarly, I wish to extend my thanks to the numerous church members that I met during my visits, who, without exception, willingly shared their knowledge and gave me an invaluable insight into the history and traditions of their churches. I also wish to thank my wife, Janet, for accompanying me when taking photographs of the various churches mentioned in the text, and my son, Jon, who read and made a number of useful corrections to the manuscript.

Finally, whilst I have tried to ensure that the information in the text is factually correct, any errors or inaccuracies are mine alone.

This edition first published 2023

Amberley Publishing
The Hill, Stroud
Gloucestershire GL5 4EP

www.amberley-books.com

British Library Cataloguing in Publication Data.
A catalogue record for this book is available from the British Library.

ISBN 978 1 3981 1391 6 (print)
ISBN 978 1 3981 1392 3 (ebook)

Typesetting by SJmagic DESIGN SERVICES, India.
Printed in Great Britain.

CONTENTS

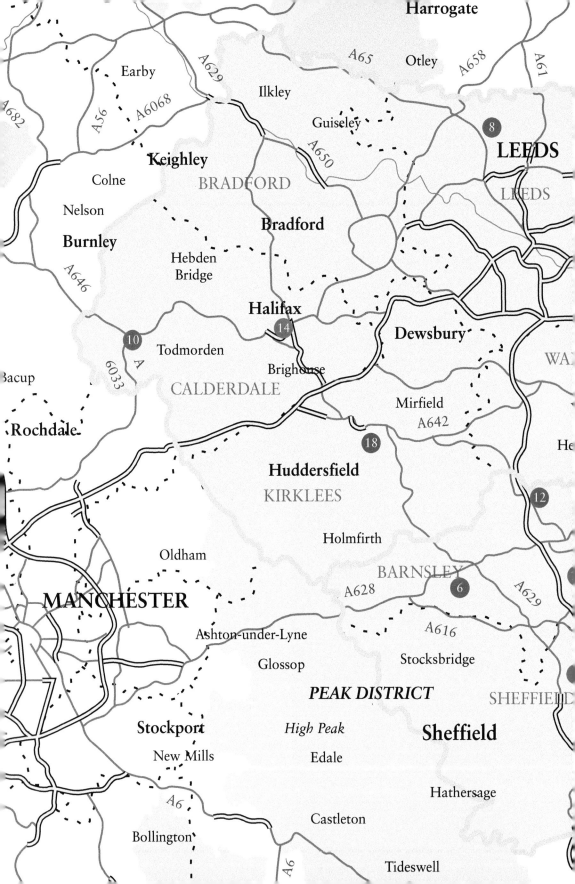

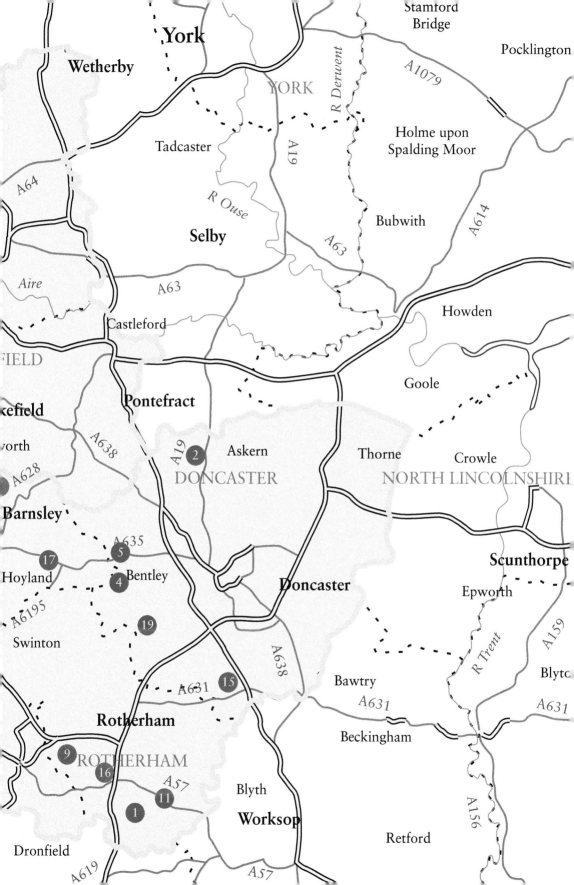

INTRODUCTION

In the vast county of Yorkshire, the largest county in England, with its proud traditions of history and heritage, it is not surprising that there is a total of some 175 Grade I listed churches. Many of the nineteen churches featured in this book date back to the time of the Domesday Book of 1086, and some have their origins in the Anglo-Saxon era. Elements of Norman architecture can be seen in the church of St John the Baptist at Adel, although most of the other churches follow a Gothic style of architecture with foundations dating between the thirteenth and seventeenth centuries. All Souls, Halifax, and the Unitarian Church at Todmorden are built in the Gothic Revival style.

Because of the age and antiquity of these churches, many were deemed to be in need of renovation and refurbishment – a practice widely adopted during the Victorian era. During these, often extensive, programmes of work, it was not unknown to uncover evidence of previous, long-forgotten, Pagan rituals. For instance, when renovations were being made at St Helen's Church, Treeton, in 1892, a small child's coffin was found during work on the south wall. It was a common Pagan tradition to bury, alive, a newborn child in the foundations of a new building. The coffin, which is now built into the west wall of the porch, was found without a lid and it was filled with dirt.

Other examples of former practices and traditions can still be witnessed, as at All Saints Church, Darton. When the monks of the Priory of St Mary Magdalene at Monk Bretton rebuilt All Saints church, an anchorite cell was incorporated into the structure. The anchorite cell, or hermits' cell, is where either a man or a woman hermit would, literally, be holed-up, or 'anchored', in the cell; here they would be in complete isolation and would be able to devote the remainder of their lives to prayer and contemplation.

This book does not purport, in any way, to be an academic text, but is aimed at the general reader.

David Paul

1. ALL HALLOWS, HARTHILL

In Saxon times Harthill was known as Hert-hyll, and opinion is divided as to the derivation of the ancient name. A popular view is that the answer lies in the village crest, which shows a hart – a male red deer.

The son-in-law of William the Conqueror, Earl William de Warenne, had vast land holdings including the manor of Harthill, which he had been awarded in recognition of the role he had played during the Norman invasion. He commissioned All Hallows to be built in or around 1080. Initially, the church was dedicated to St John the Evangelist, but little remains of that church save for the pillars and arches at the north side of the nave. During the thirteenth century the church was rededicated to All Hallows. Between the twelfth and sixteenth centuries a number of structural modifications were made to the church, including the addition of chapels and aisles. During the reign of Charles II, Thomas Osborne restored St Mary's Chapel, which included the construction a family burial vault beneath. Similar to many other churches of the period, All Hallows had a large wooden chest in which were kept important documents relating to the church and other precious artefacts. Unfortunately, the chest itself was stolen some years ago. It was not until 1856 that the church porch was added.

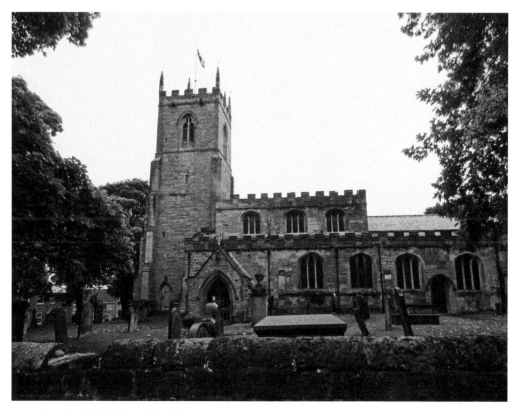

Church of All Hallows, Harthill.

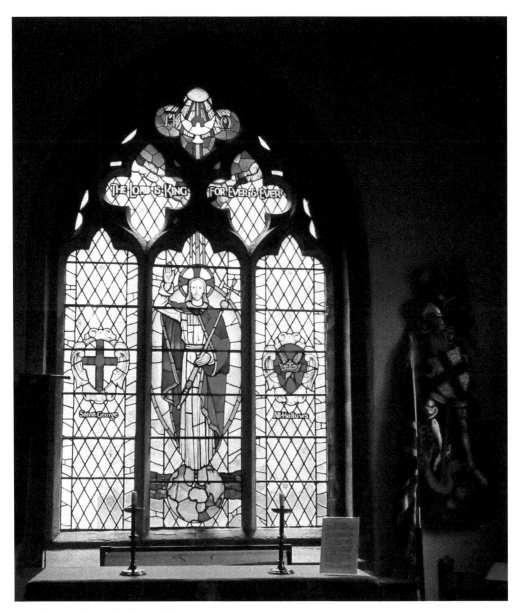

East window in St George's Chapel.

The font had a Jacobean cover, which can now be seen on the top of Sir Thomas Osborne's tomb in the Leeds chapel.

The fifteenth-century tower originally contained eight bells, but over the centuries, two of the bells were lost. The six remaining bells were dated from 1660 to 1889. They were replaced by Gillett & Johnston, bell founders of Croydon, in 1937. In 1951 the electro-pneumatic bell chiming apparatus in the tower was

installed by Gillett & Johnson in memory of parishioners who lost their lives during the two world wars. A service of dedication was held on 29 July 1951 led by the Right Reverend Bishop George Barne.

Each of the eight bells in the tower is named after a prominent person from the history of the parish:

Bell 1: William Warrene Bell (*c.* 1086)
Bell 2: Hugh Selby Bell (*c.* 1297)
Bell 3: Nicholas Kneeton Bell (*c.* 1350)
Bell 4: Edward Osborne Bell (*c.* 1550)
Bell 5: Marmaduke Carver Bell (*c.* 1660)
Bell 6: Thomas Osborne Bell (*c.* 1690)
Bell 7: John Hewitt Bell (*c.* 1745)
Bell 8: Bishop Barne Bell (*c.* 1951)

Different architectural styles can be seen in the arches in the nave, with the round arches on the north side being cut before the pointed arches on the south side. A clerestory was added below the oak timbered roof in the fifteenth century. The stained-glass windows in the clerestory are thought to be the work of the celebrated Florentine artist Ulisse De Matteis.

A gallery was built towards the rear of the nave in 1738, but, in 1850, when the north aisle was rebuilt and new seating was provided in the nave, the gallery was removed.

On either side of the tower arch are two funeral hatchments. On the left are the arms of Lady Bridget Bertie, wife of Sir Thomas Osborne, 1st Duke of Leeds, and on the right are the arms of Lady Mary Godolphin, wife of Sir Thomas Osborne, 4th Duke of Leeds. During the mourning period, hatchments were placed outside the person's home and later transferred to the church.

In the south chapel there are the pulpit, lectern and screen, all of which were carved by the Italian artist Carlo Scarcelli, the pulpit and lectern bearing the inscription '1877 Carlo Scarcelli in Legno'.

During the fifteenth century the south aisle was widened following the Perpendicular style of architecture. In the first window on the south wall are painted slated panels of the Apostles Creed and the Lord's Prayer. There is also a memorial window depicting 'Charity' by the Italian artist Ulisse De Matteis commemorating Lady Charlotte Townshend, wife of the 6th Duke of Leeds.

When the south chapel was built in the fourteenth century it was dedicated to the Holy Trinity. The south windows follow the Perpendicular style of architecture. During the restoration of 1898 the chapel became a vestry. However, in 1952 further changes were made when the area was refurbished and dedicated to those parishioners who fell in the First and Second World Wars. The chapel was dedicated to St George, with the newly glazed window depicting 'Christ in Majesty' – the creation of Faith Craft Works.

The chancel dates from the thirteenth century. There is a memorial on the north wall of the sanctuary dedicated to Lady Margaret Osborne (née Belasyse),

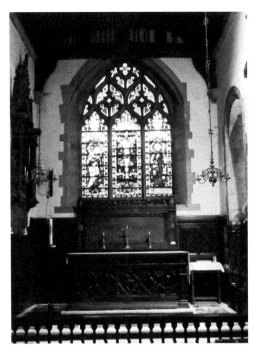

Left: East window.

Below: South side nave arches showing clerestory windows by Ulisse De Matteis.

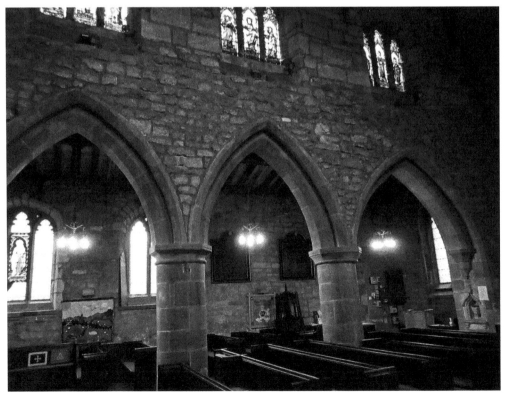

Sir Edward Osborne's first wife. The sculpture shows Lady Margaret kneeling at a desk. There is one child behind her and another in swaddling clothes.

Following an extensive refurbishment towards the end of the nineteenth century, a new chancel arch was built, and the new arches in the north side were created to match those on the south side.

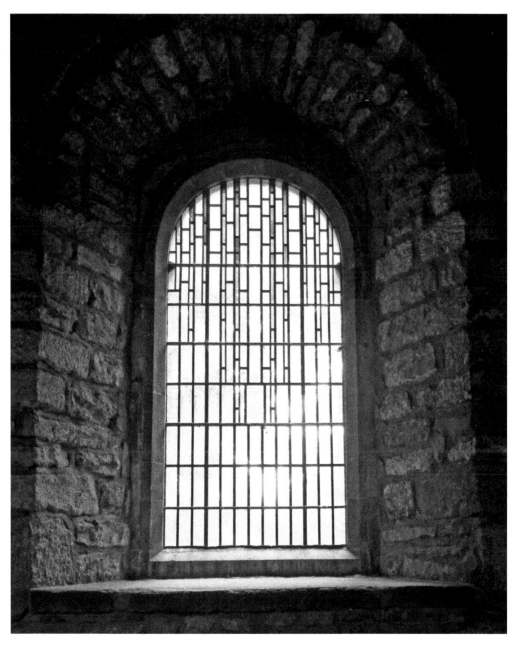

Window in memory of Mark Hydes and his son Alonzo.

A single oak tree, grown in Sutton-on-the-Forest, provided all of the church's roof beams.

The east window, inserted in 1899, is a depiction of the Crucifixion, St John and St Mary, and is by the renowned English stained-glass designer and manufacturer Charles Eamer Kempe. The window was a gift of C. W. Hudson and is dedicated to the 7th Duke of Leeds.

When the organ was rebuilt it was placed in the north chapel.

Before the Osborne family, the Serlby's were lords of the manor, and were traditionally buried in the original fourteenth-century chapel of St Mary. Sir Hugh de Serlby's tomb is near the northern wall, outside the entrance to the Leeds chapel. The tomb dates from 1298.

The marble tomb of Sir Thomas Osborne, 1st Duke of Leeds, stands behind the iron gates which are at the chapel entrance.

One of the five stained-glass windows attributed to Ulisse De Matteis, the chapel's east window, is a memorial to the widow of the 7th Duke, Louisa Catharine Hervey-Bathurst. Unfortunately, this window is now partially obscured due to the repositioning of the organ in 1898.

The gauntlets which Sir Edward Osborne is said to have worn during the Civil War can be seen in the case in the north aisle. There is also a memorial to Sir Edward on the north wall of the chapel.

Much of the chapel was rebuilt during the eighteenth century, and further changes were made in the nineteenth century.

It was Thomas Osborne, 1st Duke of Leeds, who commissioned the mortuary chapel to be built in the north-east corner of All Hallows Church. There is a painted glass window in the chapel by W. Price, which dates from 1705.

Directly beneath the Leeds chapel is the Osborne family vault, which is the last resting place of the 1st Duke of Leeds and seven successive dukes. There is a total of twenty-four coffins in the vault amongst which are included the coffins of several duchesses, and other members of the family.

The west window glass was designed by John Francis Bentley – architect of Westminster Cathedral – and dedicated to George and Dorothy Walker.

It is possible that the north aisle was widened during the fourteenth century and then completely rebuilt in the nineteenth century. The window towards the west end of the north aisle, which dates from 1886, was given in memory of Revd Hudson by his friends, and manufactured in London by Messrs Lavers, Barraud and Westlake. The window depicts both the Good Samaritan and the Good Shepherd.

The window at the west end of the north aisle was placed there in memory of Mark Hydes, a former chorister and benefactor of the church, and his son, Alonzo, who was the church organist.

Further along the north aisle there is a more recent window in plain glass by R. G. Simms.

Location: S26 7YH

✠

2. ST MARY MAGDALENE, CAMPSALL

A wooden Saxon church was founded at Campsall after the Romans left the area. Sometime later, following the Norman Conquest, when Ilbert de Laci, 2nd Baron of Pontefract and founder of Pontefract Castle, was the lord of the manor, he built the church of St Mary Magdalene, Campsall, in a traditional cruciform plan. The Norman church incorporated a chancel, nave and transepts. A western tower and aisles were added at a later date. The plan also incorporated a special room in the tower, complete with a large fireplace. The room was built, specifically, to be for the use of itinerant clergy. At that time, the lands consisted of six townships or hamlets: Campsall, Askern, Fenwick, Moss, Norton and Sutton. Although there is no reference in the Domesday Book to there being a church at Campsall at that time, it is possible that there might have been a chapel in the manor, as the current church has work from a pre-Conquest date.

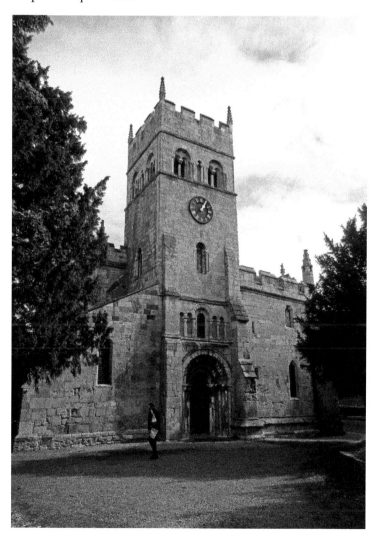

Church of St Mary
Magdalene, Campsall.

The rood screen.

Two identifiable twelfth-century building phases can be seen in the church of
St Mary Magdalene, Campsall. During the first phase, the church was cruciform
in plan. Later on, an ambitious Norman west tower was added, as were nave
aisles. Over the years alterations were made to the windows, chancel, aisle arcades
and the south doorway.

Two families, the Lacis, the chief lords, and the Reineviles, held responsibility
for the church and, until the time of Henry III, two rectors were in post, one being
appointed by each of those two leading families.

Of particular note is the beautiful, Pugin-designed altar, which is now to be seen
in the Lady Chapel, thought to have been brought to St Mary Magdalene from
the now disused chapel in Ackworth. The instruments of Christ's Passion are to
be seen on the shields, which the angels are bearing. Another one of the church's
many treasures is the fourteenth-century rood screen, which it is believed came
from the house of the Benedictine nuns at the priory of Wallingwells Abbey.

In 1481 the Benedictine nuns of the priory of Wallingwells Abbey were granted
the rectory of Campsall by Edward IV. Shortly after, in the following year, the
Archbishop of York, Thomas Rotherham, appropriated it to this purpose and
decreed that in future the benefice should be served by a vicar. He gave the right of
appointment to the University of Cambridge.

Norman arch leading to Warrior Chapel.

The baptistry ceiling.

Later on, the church's principal benefactor was the Yarbrough family of Campsmount, and several monuments in the chancel dedicated to members of the family testify to that fact. There is a wall monument by the renowned British sculptor John Flaxman, who, in 1803, was commissioned to create a memorial to Thomas Yarbrough. The memorial depicts Yarborough dispensing alms to the poor. To the south of the chancel arch there is a cartouche to Revd Francis Yarbrough and, directly below, there is a black marble slab to Anne Yarburgh. Another monument to Thomas Yarburgh can be seen over the north door. There are a number of grave slabs in the chancel floor, including those to John and William Ramsden.

Local tradition asserts that it was at the church of St Mary Magdalene that the outlaw Robin Hood married Maid Marian, the church being the only one in the area at that time!

As with a number of other villages in the area, at one time Campsall was blighted by the Black Death. A 'plague stone' can still be seen in the churchyard. Originally the stone stood on the boundary of the parish. Food was placed by the stone and anyone wishing to buy the food left money in a bottle of vinegar – thus avoiding the risk of contamination and the spread of the disease.

A major restoration of the church was carried out between 1871 and 1877 under the direction of the prolific English Gothic Revival architect Sir George Gilbert Scott.

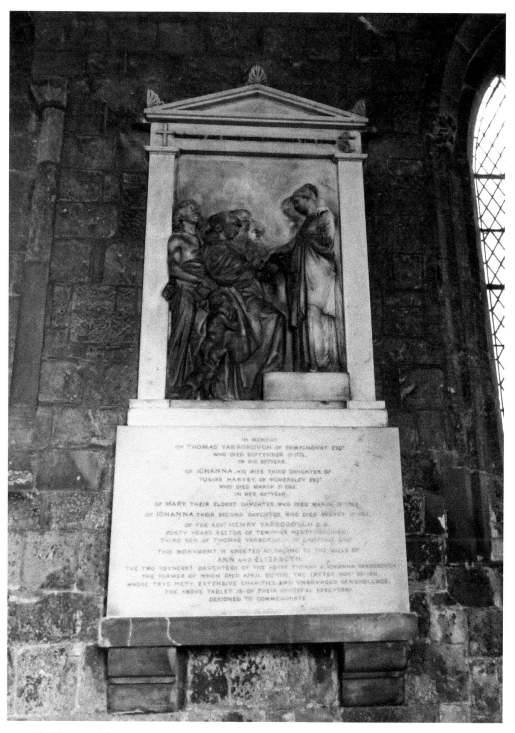

The Flaxman Monument.

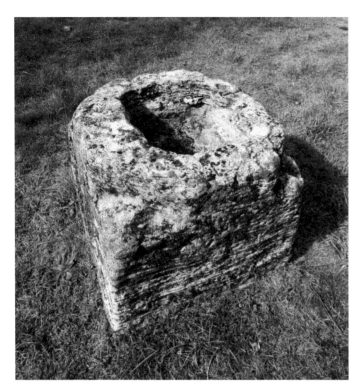

Plague stone in the churchyard.

The first eight bells were installed in the tower sometime in the sixteenth century, then, in 1879 during the incumbency of Revd Edwin Castle, three new bells were bought and the original eight bells were recast into five bells, giving a total peal of eight bells. Also at that time, a new clock was installed in the tower.

The so-called 'Founder's Tomb' is one of many ancient gravestones to be found in the church and is thought to contain the mortal remains of eleventh-century Norman knight Ilbert de Laci.

In 2005 a programme of restoration was carried out on the stonework of the tower.

Location: DN6 9LH

3. ST MARY THE VIRGIN, ECCLESFIELD

Ecclesfield is referred to as Egglesfeld in the Domesday Book, inferring that there was a worshipping community here well before Norman times. The earliest reference to a church being on this site comes in 1141, and some elements of that church can still be seen in the present building. The oldest elements within the church are the pillars in the nave, with the pillars in the north aisle being circular, whilst those in the south aisle are octagonal. The overall plan of the present church

is similar to the fourteenth-century church, having a nave, north and south aisles, central tower, transepts and chapels.

Shortly after the Norman Conquest, the Norman Lord of Hallamshire, William de Lovetot, gave Ecclesfield to a Benedictine order of monks based in Normandy. Some monks were based at Ecclesfield, although they failed to exert any religious influence on the area. Towards the end of the fourteenth century, the upkeep of the chancel passed to the Carthusian Priory of St Anne. Following the dissolution of the order, the church was given back to the Lords of Hallamshire.

In 1478 Thomas Clark, the then vicar began the building of the present church. The structure was completed by the turn of the century.

The arrival of Revd William Ryder as vicar of the parish coincided with a significant increase in the local population. During his time as vicar, Ryder re-roofed the nave and chancel, installed oak pews and had a number of galleries installed around the church. Having completed the remodelling of the church, Ryder resigned. However, much of this remodelling was reversed when Revd Dr. Alfred Gatty became vicar in 1839. There is a marble tablet in the nave commemorating Margaret Gatty, wife of Revd Gatty. The tablet was placed there by more than 1,000 children in gratitude for the many books she wrote for them. Another tablet commemorates Margaret Gatty's second daughter, Juliana Horatio

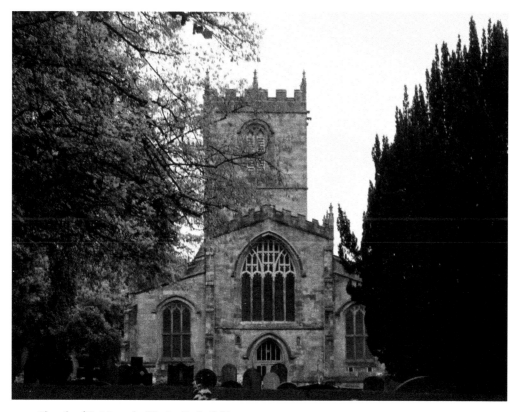

Church of St Mary the Virgin, Ecclesfield.

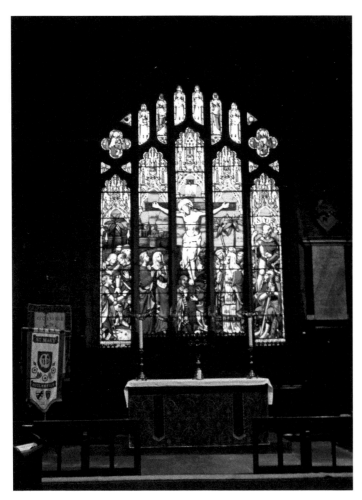

East window.

Ewing, who was also a writer of children's books. Indeed, the Brownie movement was inspired to take its name from one of her stories.

The 'Green Man' is in evidence in St Mary's Church, especially in a number of the roof bosses. The 'Green Man' is often seen surrounded by leaves, and represents the cycle of new growth that occurs every spring; the 'Green Man' is regarded by many as a symbol of rebirth.

Similar to many other fonts in churches following the Perpendicular style of architecture, the font at St Mary's, which dates from 1662, is octagonal in shape. The shape is symbolic; seven sides represent the seven days of creation, and the eighth side represents new creation in Jesus Christ.

In 1876 the pulpit was given in memory of William Frederick Dixon and his wife by their surviving daughters. The panels on the pulpit were carved in Antwerp and depict scenes from the life of St Paul.

In 1901 the organ builders Brindley and Foster of Sheffield built and installed a new organ in the north transept. The organ was enlarged and overhauled

Looking from the chancel towards the west window.

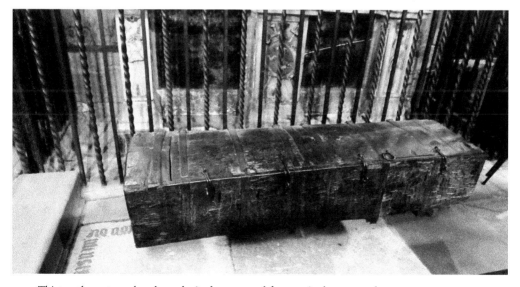

Thirteenth-century churchwarden's chest, carved from a single tree trunk.

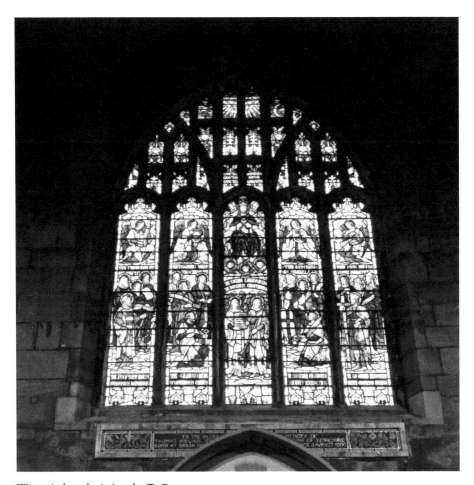

West window depicting the Te Deum.

in 1973. Following a number of technical difficulties, the organ was again overhauled in 2000.

There is now a ring of ten bells at St Mary's, but throughout the seventeenth century the church had only four bells, the oldest having been cast in 1590. In 1745 another two bells were added and then, just one hundred years later, a further two bells were added in 1845, making an octave of eight bells. The last two bells, gifted by Janet Gledhill, were added in 2011, making a ring of ten bells in total. There is also a Sanctus bell in the belfry that dates to 1580; the bell was originally chimed to alert people in the village that Mass was being celebrated.

The base and cross shaft of a Saxon cross can be found within the church. It is thought that, originally, the cross would have been used as a 'preaching cross' by itinerant priests.

There are several hatchments on the wall above the west door, featuring those of a number of leading local families including the Shirecliffes, the Dixons and the Foljambes.

The colours of the Ecclesfield Volunteers can be seen on the north wall of the church. The group was formed in 1803 as a defending force during the Napoleonic wars.

There is a thirteenth century Churchwarden's chest carved from a single tree trunk. The chest has four locks with four separate keys, thus preventing any of the churchwardens opening the chest without the others being present. The contents of the chest included churchwarden's accounts, church registers and other important documents. Unlike many other churches, St Mary's still retains four churchwardens.

The act passed by the Puritans in 1643 stated 'all representations of any angel or saint in any ... parish church ... was to be taken away, defaced and utterly demolished'. As a result, many of the decorative artefacts of St Mary's were lost, as was all of the stained glass. However, some of the fragments of glass that did survive were incorporated into windows in the north aisle and the vestry.

The West Window depicts the Te Deum – the Church's Hymn of Praise – and was inserted in memory of Thomas William Jeffcock, J.P.

The Parables from Nature window is dedicated to Margaret Gatty, wife of Revd Gatty, and the five upper lights represent the Sermon on the Mount, whereas the five lower lights have illustrations from five of Jesus' parables.

The Ascension is depicted in a window on the church's north wall and is dedicated to Juliana Gatty, daughter of Revd Gatty.

The earliest marked grave in the churchyard is that of Revd Richard Lorde, who was vicar of Ecclesfield from 1585 to 1600, the year in which he died.

The vault of Revd Alexander John Scott D.D. is on the north side of the church. Revd Scott was chaplain to Lord Nelson at the Battle of Trafalgar. Nelson died in Scott's arms on HMS *Victory*. Scott himself died whilst on a visit to his daughter, Margaret Gatty, wife of the then vicar of Ecclesfield, Revd Dr Alfred Gatty.

The war memorial in the churchyard, designed by R. B. Brook-Greaves, has, on three sides, name panels for the fallen from three conflicts; fifty-four personnel who lost their lives during the First World War, thirty-six personnel who lost their lives during the Second World War, and one man who lost his life in the Falklands War.

Location: S35 9XZ

✠

4. ST PETER'S, BARNBURGH

It is known that there was a church on this site as early as 1150, but nothing remains of this earlier building. The first Norman church built at Barnburgh had an aisleless nave and chancel at the east end of the church. There was also at that time a three-stage tower, which was unusual for church buildings at that time.

The north aisle was added to the nave some fifty years later. Traditionally, church extensions tended to be on the north side of the building, as people preferred not to be buried on that side of the church, claiming that they didn't want the shadow of the church falling upon them.

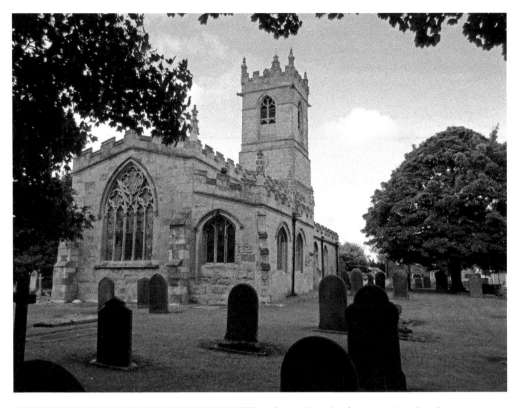

Above: Church of St Peter, Barnburgh.

Left: South side priest's door.

At the beginning of the fourteenth century there was a major rebuilding of the church, carried out, it is thought, under the direction of the English mason Henry de Eynsham; the north aisle was enlarged, the south aisle and porch were built, the chancel was rebuilt and a north chapel was added. Also, both the tower and chancel arches were rebuilt. Corner buttresses were built so that the additional two stages could be added to the remaining two stages of the tower. A small spire was also added to the tower at this time.

Early in the fifteenth century clerestory windows were inserted in order to create extra light within the church – the windows on the south side of the church are two light windows, whereas those on the north side are three light windows. The 'Decorated' windows, which had adorned the aisles, were replaced with larger 'Perpendicular' windows.

Apart from the upper stage of the tower being rebuilt in 1859, there have been very few structural changes in the church. In 1869, however, there was some restoration in the church when the east window and the windows in the chancel were replaced. The Cresacres and the Bella Aqua's would have, in all probability, funded the rebuilding programme. Documentation in the form of chantry certificates verifies that there were two chantry chapels at Barnburgh church. The Cresacres and the Bella Aqua's founded the chantries.

On the north side of the church there are two blocked-up doorways, one which gave access to the north chapel, and would have been used, solely, by members of the Cresacre family and their chantry priest. The other door, nearer to the tower, was known as the 'Devil's Door' and was only opened during special services such as baptisms. The significance of the opening of this door was to allow an exit for the Devil; the practice of opening the 'Devil's Door' ceased after the Reformation.

The original Norman font at the entrance to the church dates from the latter part of the twelfth century.

North of the chancel there is the private chantry chapel for the Cresacre family. A Gothic Revival arcade separates the chapel from the chancel. The chapel contains the wooden 'Cat and Man' effigy that is thought to be Sir Percival Cresacre, who died in 1477. Sir Percival is shown in plate armour together with a conical helmet. He is holding a heart in his hands, which is, conceivably, one of his ancestors, Sir Thomas Cresacre. Also in the chapel is the slab tombstone of the wife of Sir Percival, Alice Cresacre, and a brass to another member of the family, Anna Cresacre. There are also two mural tombstones to the Vincents of Barnburgh Grange. The organ, which stands under one of the two arches between the chapel and the chancel, was a gift in 1829 from Henrietta Griffith of Barnburgh.

Near to the first pillar in the north aisle there is the shaft of what was a Saxon preaching cross. Before there was a church at Barnburgh people would congregate around the cross to listen to itinerant preachers. Two fragments of the cross were found in the churchyard. The shaft that can now be seen in the church was erected there by Revd W. R. Hartley.

Prior to the Reformation the church had many stained-glass windows but, following the turbulence, little remained, save for the upper lights of the east window in the south chapel.

In 1904 the nephews and nieces of John Hartop of Barnburgh Hall, a great benefactor of Barnburgh church, had a window placed in the south wall of the chancel in his memory.

In 1906 Mrs Mary Hartop donated the window behind the font to the memory of her sister. Then, in 1914, the window in the north aisle on the other side of the tower arch was dedicated to the memory of Mrs Mary Hartop. Archdeacon Clarke had a window inserted in 1946 at the east end of the south chapel in memory of his wife.

There is much discussion concerning the function of the diamond-shaped hole in the north wall of the north aisle. Some observers believe that it was a 'lepers squint' or hagioscope, which enabled those who were forbidden entry to the church, such as lepers, to view the high altar whilst the Host was being raised. The position and size of this opening have caused others to question this supposition.

Originally, the church of St Peter had a peal of three bells. However, it became apparent in the 1990s that, unless urgent action was taken, the bells would become unringable. Accordingly, in 1993 a new frame, capable of holding five bells, was installed. The three bells were refurbished and rehung. Then in 1996 St Peter's was awarded a grant under the Millennium Commission's Ringing in the

Stone coffin in church grounds.

Millennium funding, which enabled the church to augment the ring to five bells by the addition of a treble and a tenor. Both bells are second hand. The treble, cast by T. Mears of London in 1829, came from the redundant church of Christ Church, Doncaster. The tenor bell, cast in 1853 by C. & G. Mears Founders of London, came from Longton in Staffordshire. The augmented ring of five bells was dedicated on 16 July 2000. Access to the bell chamber is via a freestanding wooden spiral staircase.

The legend of the cat and man has long since passed into local folklore. The tale, reputedly, relates to a certain Sir Percival Cresacre who lived at Barnburgh Hall during the fifteenth century. One night, after spending some time over at Doncaster visiting friends, he was returning home along the bridleway. As he was riding down Ludwell Hill a wild cat suddenly sprang from a nearby tree onto the back of his horse. Desperately trying to remove the attacking animal, the horse shied, but did little more than unseat its rider before galloping away. The wild cat then turned its venom and fury onto the horseless rider. What ensued was a deadly struggle between the knight and the wild cat, which lasted all the way from Ludwell Hill to Barnburgh. Now nearing exhaustion but within sight of St Peter's Church, Sir Percival attempted to gain access in order to shield himself from the animal. However, his energy failed, and he fell dying in the church porch, but, summoning a last heroic effort, he managed to use his feet to crush and kill the cat against the wall of the porch. When the knight's riderless horse returned to Barnburgh Hall a search party was sent out and, sometime later, discovered the knight's body. So, as the tale tells, the cat killed the man and the man killed the cat. There are said to be stones in the porch floor that are tainted with red.

Location: DN5 7ES

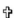

5. St Wilfrid's, Hickleton

The village is mentioned in the Domesday Book, but there is no reference to there being a church in the village. It is possible that a chapel of ease was built at Hickleton sometime between 1050 and 1100, but it has also been suggested that, between 1170 and 1177, when Jordan was the parson, he established Hickleton as being the mother church of Barnburgh. However, what is indisputable is that, in 1201, a partition gave Hickleton to Ralf de Neufmarche. Then, following a disastrous fire at the Priory of Monk Bretton, the church and all of its lands were gifted to the priory by Archbishop Neville of York in 1386. Until the priory was dissolved and the Crown disposed of its land and wealth, the church at Hickleton was a beneficiary of much of the priory's wealth, which was created from the woollen trade.

It has been established from archaeological excavations that the current church building dates from the middle of the twelfth century, although, in all probability, there was a church on this site in Saxon times. The Norman chancel arch and the font would indicate that, originally, the church simply consisted of a nave and

chancel. However, the porch and the western end of the nave date to the beginning of the fourteenth century. The church was extended in the fifteenth century with the addition of an aisle and a chapel on the north side. The church follows the Perpendicular style of architecture.

St Wilfrid's has a double-aisled nave and chancel. The vestry and Lady Chapel on the north side are Victorian, whereas the Halifax Chapel on the south side is much older.

Above: Church of St Wilfrid, Hickleton.

Left: Circular Norman font.

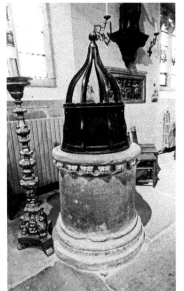

The 1st Viscount Halifax began a major programme of refurbishment in 1876, but, owing to his untimely death in August 1885, the programme was ultimately completed by his son in 1888. The programme of restoration was carried out under the direction of the English Gothic Revival architect George Frederick Bodley of Durham. At the beginning of the restoration, the plan of the church included a nave and a north aisle of two bays, a single bay south aisle with a porch to the west of it. The church also had a western tower, and a chancel and south aisle of two bays. The restoration included the addition of a new north aisle and sacristy. Also at this time the sanctuary was paved, new screens were added to enclose the altar and the roof was raised and renewed. Much of the cost of the restoration was defrayed by Lord Halifax. Most of the stained glass, including the glass in the east and west windows, and the glass in the south and north chapels, was gifted to the church between 1886 and 1887, forming an integral part of the restoration. There is a distinct possibility that some of the original painted glass in the windows was reused during the Victorian refurbishment. The transformation of the pulpit from being two-tier to being a single-tier pulpit was also paid for by members of the Halifax family, as were many of the other furnishing in the church, including the gallery and the old box pews being removed.

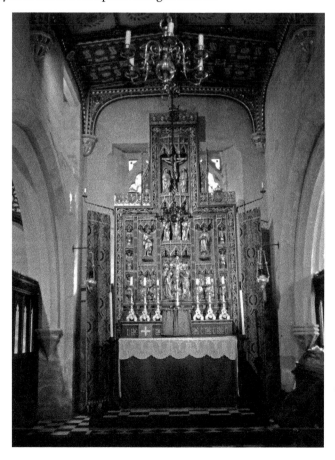

High altar.

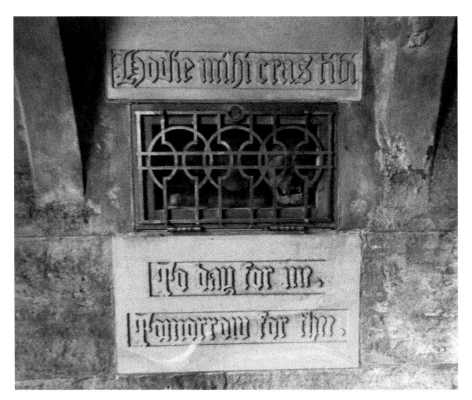

Human skulls behind grill in lychgate.

The various shields are representative of the leading families of the parish of Hickleton.

The second major restoration work, which was carried out between 1982 and 1986, became necessary when it was discovered that there was a geological fault and mining subsidence in the immediate vicinity. The restoration was funded by the National Coal Board. The remedial work necessitated significant areas of the church, including the Halifax Chapel, the Lady Chapel and the Baptistery, being dismantled and a concrete base being installed under the church's foundations. The platform, which incorporated a series of hydraulic jacks, enabled corrections to be made should any further subsidence occur. On completion of the work, the chapels and baptistery were then reconstructed. During the excavation work, the remains of people who had been buried in those areas were uncovered. These remains were then, with due dignity, relocated to more suitable places of rest in the churchyard.

Some painted window glass, dating from the thirteenth century, was discovered at the time of the excavations.

The church has a ring of three bells. The first was cast by an unidentified founder; the second bell was cast in 1658 by George I Oldfield of Nottingham; and the third bell was cast in 1676 by William Cuerdon of Doncaster.

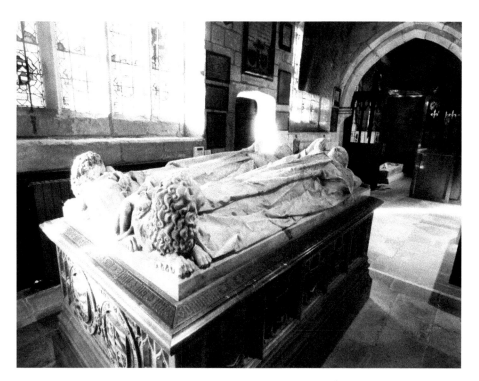

Above: Monumental tombs in Halifax Chapel.

Right: Norman chancel arch.

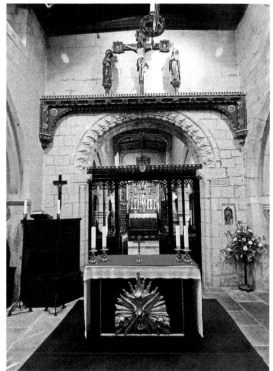

Set behind a grille in the church's lychgate are three human skulls, above which is a statement written in both English and Latin. The sombre message, to all who care to reflect on the words, simply states: 'Today for me, Tomorrow for thee'. Local tradition claims that the skulls are those of three sheep rustlers who were caught and hanged at High Melton; however, it is thought more likely that the skulls were placed there by Lord Halifax to serve as a reminder of the inevitability of death.

Location: DN5 7BA

6. ST JOHN THE BAPTIST, PENISTONE

The church of St John the Baptist, Penistone, is often referred to as Penistone parish church. Traditionally, it is thought that Sweyn of Hoylandswaine established a church at Penistone sometime in the twelfth century, and records verify that there were priests attached to the church as early as 1200. One of the internal pillars that is near to the pulpit has the remnants of an Anglo-Saxon cross-shaft incorporated into its construction indicating that there has been Christian witness on this site for in excess of 1,000 years. Also, it is considered that the church itself is built upon the foundations of an earlier church, which dates from around AD 900.

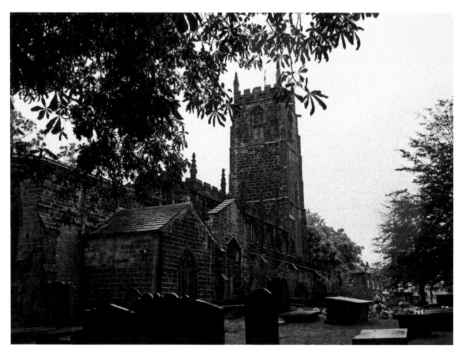

Church of St John the Baptist, Penistone.

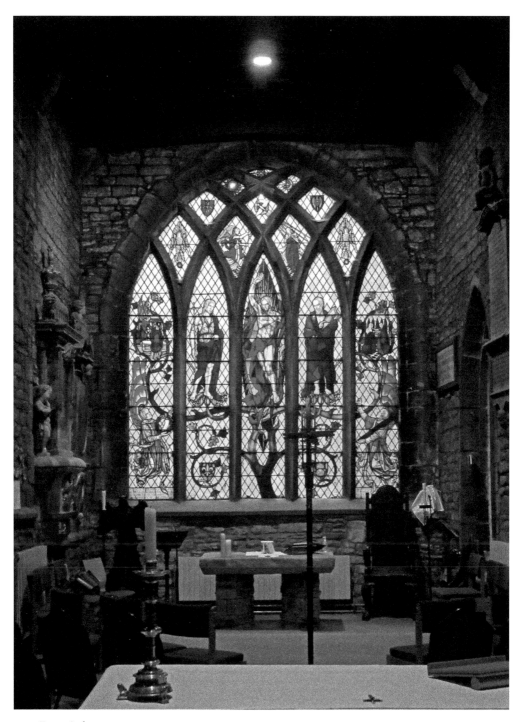

East window.

Similar to a number of other churches across the country, tradition declares that, originally, the church was destined to be built at another location, Snowden Hill, but that every night, when building work had finished for the day, the masonry was spirited away by an unknown agency and delivered to the Penistone site. Suffice it to say, the church at Snowden Hill was never built.

The Archbishop of York's accounts of 1232 record Penistone church as being dedicated to St John the Baptist. There is also reference to priests being at Penistone in the document, dating from the beginning of the thirteenth century. The first vicar of the church, Thomas Bryan, was instituted 23 January 1413. Up until that time local landowners had assumed the role of rector, the first being Henry de Barton, who was presented by Sir John de Burgh on 13 October 1281.

Left: Font.

Below: Funereal hatchments.

The gritstone from which the church was built was quarried at Harden Clough. The gargoyles around the church are ugly by design, and are meant to be a protection against sin.

The Perpendicular-style Norman west tower dates from 1500 and stands some 80 feet high with a peal of eight bells.

There appears to have been two chantry chapels in the church at one time, the chapel in the north being dedicated to St Erasmus, whereas the chapel in the south was dedicated to Our Lady. The chapel in the north later became the church vestry.

Later on, in 1702, the porch was built reusing stone from St John's chantry, which was attached to a hermitage along Chapel Lane. In all probability, the chantry chapel fell victim to the 'Dissolution of the Chantries Act' of 1547, during the reign of King Edward VI.

Sometime before the church clock was placed on the west face of the tower, there had been a 'scratch dial' that gave an indication as to when church services were beginning. There was an outlay of £3 4s in 1698 when it became necessary to repair the clock. Then, on 10 April 1817, Easter Sunday, a new clock installed at a cost of £87. By the turn of the century the clock was becoming unreliable and, following a meeting of the Parochial Church Council on Wednesday 28 May 1924, it was decided that it should be replaced. At that time the opportunity was also taken to fit a second face on the south side of the tower and to recast and rehang the bells.

When the church tower was built a total of six bells were installed. From then until the late nineteenth century, the bells were rung every day and followed a set pattern; in the morning, at noon and at eight o'clock in the evening on weekdays, although the bells did not ring on Saturday evening. On Sunday, the bells rang at seven o'clock in the morning, again at eight o'clock and finally at one o'clock in the afternoon. In addition to the usual ringing, which included weddings and funerals, the bells were also rung for special occasions such as royal happenings or following directives from the government of the day.

A tragic accident occurred in the bell tower in August 1822. At that time Robert Bramall was the church sexton and, amongst other duties, he was one of the church's bell ringers. On the fateful day, when a bell-ringing event was being held, Robert's tenor bell overturned and he was lifted some five yards off the tower floor. Unable to hold on, Robert fell and went crashing to the floor. He died of his injuries a few days later.

Sadly, in 1835, another tragedy occurred in the bell tower. When the sexton was ringing one of the bell stays broke, which caused him to be pulled to the roof of the tower. He too died as a result of the injuries he sustained.

Messrs Taylor & Sons, the bell-founders of Loughborough, were commissioned to write a report on the condition of the bells. As a result of this report, a public meeting was held in Penistone on Wednesday 6 February 1924 to consider the recommendations. It was agreed that the bells should be recast and rehung and, further, that two smaller bells should be added, making a ring of eight bells. Venerable Archdeacon Harvey of Huddersfield dedicated the clock and bells on

Monument in Heritage and Sensory Garden.

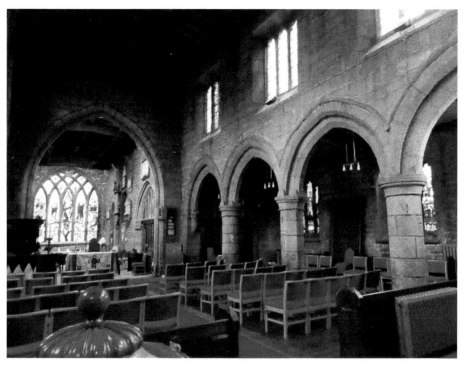

South side nave arches.

20 December 1924. The first full peal of 5,184 changes of Kent Treble Bob Major was heard across the town on 3 January 1925.

There are many examples of ancient stained-glass windows in the church, together with a more modern window, which was installed in 1992 to celebrate the 600th anniversary of Penistone Grammar School.

The clerestory windows, which were added during the fourteenth century and are directly above the pillars and arches, were added so that more light could enter into the church.

The south aisle contains two twentieth-century stained-glass windows. One, by a student of William Morris, tells the story of Jesus preaching from a boat, whereas the second window, by Frederick Walter Cole, depicts the childhood and ministry of Jesus.

The stained-glass east window is based on the Jesse Tree and also shows the risen Lord, John the Baptist and Isaiah.

One of the windows in the chapel was inserted to mark the wedding of Godfrey Bosville of Gunthwaite and Bridget Hotham in 1681. During the Tudor and Stuart periods the Bosvilles were the most prominent family in area.

'A pare of organs to the Churche of Penniston' and 'a plainage book for the organs' were donated in 1542 by the then vicar, Richard Wattes. Sometime later, in 1768, another organ was purchased for the church by public subscription. Then, on 27 June 1803 a new organ was installed in a gallery at the west end of the

church. Salem United Reformed Church of Bradford gifted an organ to St John's, which was installed in 1975.

There is a benefactor's board, which was originally located in the tower but is now prominently displayed in the aisle. The board makes reference to an act of charity by William Turton, a local landowner who, in 1559, bequeathed a legacy for the purpose of poor relief. Turton decreed that 'one Quarter of Rie to the Poor of the Parish of Peniston to be distributed yearly on Good Friday'. The tradition, known as the Turton Flour Dole or the Easter Flour ceremony, was revived sometime in the early twentieth century and is still observed to this day.

The arms of the Savilles of Ingbirchworth are shown on the hatchment. The hatchment, after being hung over the doorway of the family member's house, would then form part of the funeral procession, before being displayed in church.

As a memorial to Revd Canon William Turnbull, who served as vicar of the church from 1855 until 1915, the lychgate was built in 1959. In 1975 a stainless steel weathervane, in the shape of a fish, was made and donated to the church by Arnold Lesley Smith, a local resident.

In 2006 a Heritage and Sensory Garden was created in the lower end of the churchyard.

Location: S36 6DY

✟

7. St John the Baptist, Royston

The church of St John the Baptist, Royston, was built in 1234 by the monks of the Priory of St Mary Magdalen at Lund. The priory, founded by Adam Fitz Swain, was also known as Monk Bretton Priory, and although there were close ties between the church and the priory, any relationship between the church and the monks would have ended in 1539 when the priory closed during the Dissolution of the Monasteries. The earliest part of the present church is at the eastern end of the chancel, with the north and south walls being described in the latter part of the thirteenth century as being 'newly built'.

The great west tower was built towards the end of the fifteenth century and followed the Perpendicular style of architecture. The tower has an unusual five-sided oriel window which is at the same level as the ringing chamber of the tower.

The discovery of a fragment of an Anglo-Saxon cross – now displayed to the right of the high altar – together with the uncovering of some early foundation work, would suggest that there might well have been a religious foundation on the site as early as Saxon times.

All the roofs of the church are medieval, and those in the nave and aisles have finely carved bosses. The depictions on the bosses include the head of St John the Baptist, the Green Man, the Pelican in her piety and the Agnus Dei. At the east end of the north aisle the steps which lead to the original rood loft can still be seen.

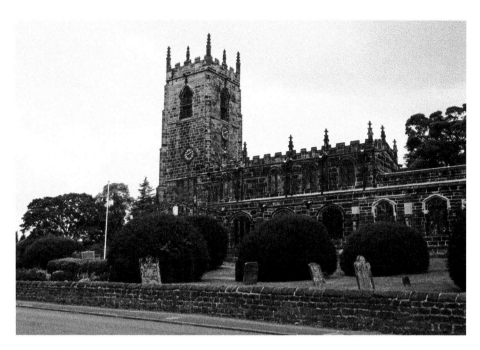

Above: Church of St John the Baptist, Royston.

Right: East window, depicting scenes from the life of Our Lord.

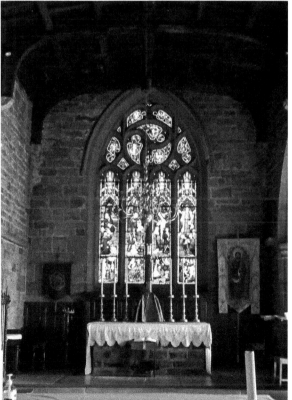

Between 1867 and 1869 a comprehensive programme of restoration was carried out under the direction of the British Gothic Revival architect John Loughborough Pearson. During the restoration the north-west door was blocked up and was replaced by a window, the level of the floor was lowered and the gallery, which stood at the western end of the nave, was removed, and all of the paint and plaster, which originally covered the whole of the church, was completely stripped from the walls. There is, however, a text from Amos 8, verses 4–7, painted on the pillar opposite the font.

Queen Victoria's Diamond Jubilee was commemorated in 1898 when a clock mechanism was installed. There was some restoration work carried out to the faces in the early 1970s.

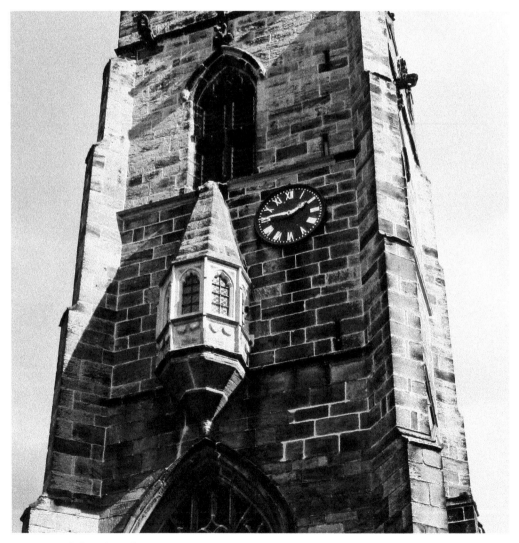

Five-sided oriel window in tower.

Medieval roof.

Further major reordering of the chancel occurred during the 1980s, when a pre-Reformation altar stone was discovered buried in the floor of the sanctuary. Following restoration, the base upon which the altar stone now rests includes stones from Monk Bretton Priory, the shrine of Our Lady of Rocamadour in France, and the former National School of 1844.

John Richard Clayton and Alfred Bell designed and installed the glass of the east window in 1885, which depicts scenes from the life of Our Lord. William Wailes of Newcastle designed and installed the first two windows in the south aisle. The other window was designed by Mayer and Company of Munich. Wailes also designed the west window and one of the windows in the north aisle. The window at the head of the north aisle is designed by Clayton and Bell of London. There are some fragments of medieval glass dating from the fourteenth and fifteenth centuries in the top lights of the Lady Chapel and Sacristy windows, but most of the church's stained glass dates from Victorian times. The Lady Chapel was reordered in 1904 and the upper lights of the east window, by Burlison and Grylls, depict the Annunciation of the Lord, whereas the lower part of the window, inserted in 2002, is by Simon Harvey of York.

Left: Nave looking towards the west window.

Below: North side aisle, showing clerestory windows.

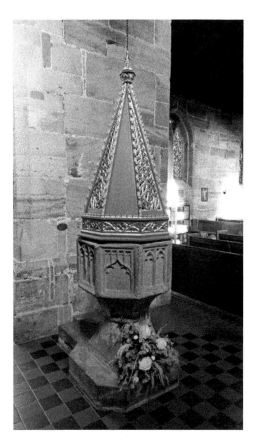

Octagonal font.

There is now a peal of eight bells in the tower, the original six being recast in 1946, with an additional two bells, from the bell founders Taylor of Loughborough, being added in 1979. The original number five bell, the Sanctus bell, dates to 1530.

In 1959 Martin Dutton's tower screen was refashioned as the utility room door at the west end of the north aisle.

Sometime in the 1980s Peter Larkworthy restored and fitted the rood beam, which had been carved in the 1930s by Read of Exeter and had been rescued from a redundant church at Gildersome, near Leeds. The Stations of the Cross, which can be seen around the walls of the aisle, were painted by Craig Hudson of Sheffield in the 1980s. In 1993 a local sculptor, Steve West, made a statue of St John the Baptist.

There was further remodelling of the west end of the church between 2001 and 2002, when the late fifteenth-century font, which incorporates a twentieth-century cover, was also moved to its present position.

Location: S71 4QZ

✠

8. ST JOHN THE BAPTIST, ADEL

The manor of 'Adele' is recorded in the Domesday Book, and a charter from the eleventh century makes reference to the church of St John of Adela. The origin of the word 'Adel' is derived from the Anglo-Saxon word 'adela', meaning a muddy or a boggy place.

The original Norman church is thought to have been built sometime between 1150 and 1170. It is evident that the church is one of the oldest Norman structures in the county. The figure of a man on horseback armed with a spear and shield, which can be seen on one of the capitals in the chancel arch, testifies to the church's age.

There is a memorial window to Colonel Arthur Bray in the nave. The window, by Frederick Charles Eden, is known as the Norman History Window. St Martin of Tours, who founded a monastery at Marmoutier in Normandy, is shown in the top centre giving half of his cloak to a beggar. Abbot Alan, who is shown in the centre panel of the window, later sent monks from this monastery to York, and it was these monks to whom Ralph Paganel endowed the wooden Adel Church in 1089. Using stone from a local quarry, the monks later rebuilt the church. The other two panels depict, on the left, Ralph the Lord of Adel Manor, and, on the right, Ralph's Norman overlord, Ilbert de Lacy.

The Cistercian abbey at Kirkstall was founded in 1152, and during the twelfth and thirteenth centuries some of the farmlands belonging to the old parish of Adel were given to the monks at Kirkstall.

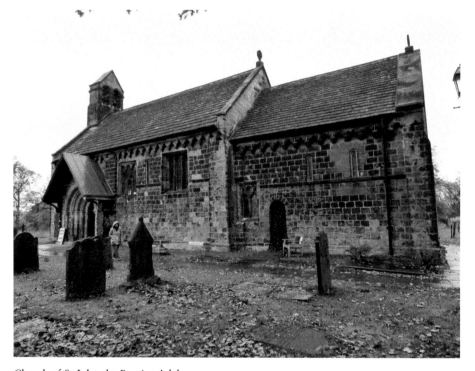

Church of St John the Baptist, Adel.

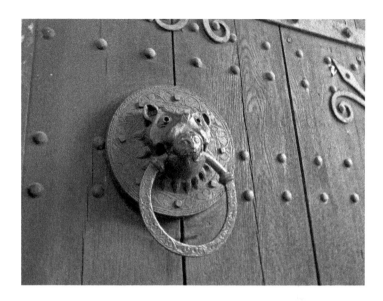

Adel sanctuary ring.

The church of St John the Baptist has a ground plan consisting of a chancel and a nave.

Original Norman narrow lights can still be seen in the east wall. Much of the Norman church remains, although a number of alterations were made to the church in both the fourteenth and sixteenth centuries. Then, between 1838 and 1839, under the direction of the noted architect Robert Dennis Chantrell, a vestry with a three-light armorial east window was built on the north side of the chancel. Also in the vestry are two of the hatchments that were once in the chancel. The west gable and the double bellcote were also added at that time. The bellcote houses three bells, two hanging in the northern arch and one which is in the southern arch. All three bells were recast by Thomas Mears of London in that year, and are marked with the following inscriptions: 'Glory be to God on high', 'On Earth Peace', and the third bell bears the inscription 'Good will towards Men'. The bells were retuned at the foundry of John Taylor of Loughborough in 1976 before being restored in 2010. There is a console in the vestry which enables the bells to be chimed by electric clappers.

Since the large stone porch was removed in 1816, much of the sculptured stonework around the south door has deteriorated.

Further alterations were made by Chantrell in 1843 when the chancel roof was restored, and again in 1879 when the nave roof was replaced.

There is a small priests' doorway in the south wall of the chancel.

The two-light lepers' window in the chancel contains a small panel of coloured glass, painted and given by Henry Gyes of York as a tribute to Thomas Kirke.

As a result of the 1879 restoration one of the chancel windows was removed and the window returned to its original Norman style.

On the south side of the church is the magnificent Norman doorway which has four levels of elaborately carved arches, with a number of symbols including the

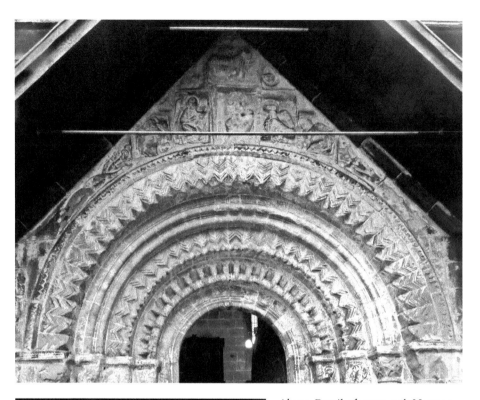

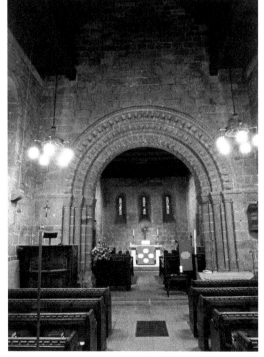

Above: Detail of seven-arch Norman porch.

Left: Looking from the nave towards the chancel.

sun and moon and the lamb and flag. The thirteenth-century bronze sanctuary ring – door knocker – on the boarded door, which depicts a monster swallowing a man, needed to be replaced in 2002 after the original sanctuary ring, which was cast in York in 1200, was stolen.

The chancel arch has thirty-seven grotesque beakheads. There are also detailed carvings on the capitals of the supporting pillars of the chancel arch depicting the Baptism of Christ, the Crucifixion, and a centaur with a bow and a horseman carrying a spear and shield.

Standing at the west end of the church there is a grit stone octagonal font – thought to be the original font – which was found in the churchyard in 1859. In 1921 Eric Gill carved an intricate oak canopy depicting the Crucifixion, six of the sacraments and a Christian arriving in heaven.

Ernest William Beckett of Kirkstall Grange, 2nd Baron Grimthorpe, presented the linenfold style oak pulpit to the church in memory of his wife who died in 1891.

Near to the churchyard gate there are two Norman stone coffins and some Roman and Saxon stones.

Location: LS16 8DW

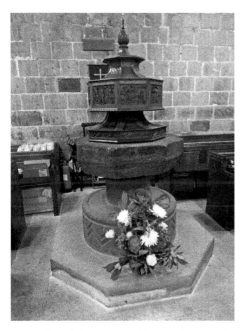 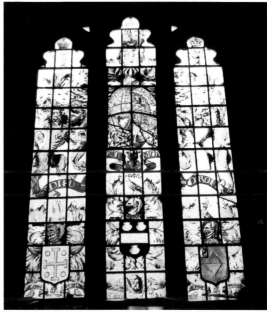

Above left: Octagonal font and cover. The eight carved panels on the font cover depict the path of the Christian pilgrim.

Above right: The lion and the unicorn window by Henry Giles.

9. St Helen's, Treeton

Reference is made to Trectone (Treeton) in the Domesday Book, the church being the only one referred to as being in the region of Hallamshire. It is not known when the Anglo-Saxon church was built, but estimates vary between 700 and 1050. The church, dedicated to St Helen, would have been very different from the present church, being simply composed of a nave, without any aisles, and a chancel. Before rebuilding the church, the original Anglo-Saxon church would have been demolished, as was the Norman practice, and a completely different church erected in the Norman style of architecture. The rebuilt church was completed sometime during the latter part of the twelfth century, having a north aisle and arcade, and possibly a south aisle, although no evidence of this now remains.

The arches of the original Norman church are still in evidence, but, other than that, save for a small child's coffin, nothing from the Norman era remains. The coffin was discovered during the church restoration of 1892 and is believed to have been part of the foundations of the south wall. A pagan tradition from a previous era had been to bury a newborn child in the foundations of a new building. The coffin has now been incorporated into the west wall of the porch.

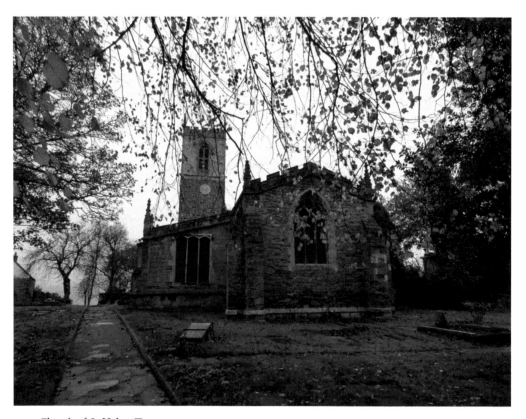

Church of St Helen, Treeton.

Church porch.

At the western edge of the church what remains of the lower part of the square, twelfth-century tower can still be seen.

There is an effigy of a thirteenth-century medieval knight which is built into the western wall of the church. Some sources consider the effigy to be that of the Earl of Shrewsbury and refer to it as 'Sir Gilbert', whereas others believe it to be Sir Christopher Talbot, second son of the Earl of Shrewsbury. Sir Christopher was lord of the manor of Treeton and lived at Sheffield Castle. It is interesting to note that there is a carving of the Talbot hounds in one of the sixteenth-century pew ends in the south aisle.

The church was remodelled towards the end of the thirteenth century. The nave was extended at the west end during the fifteenth century in order to align with the tower. Also, the southern porch was added at this time, as was the upper section of the tower and spire. During the sixteenth century, the Brampton chapel was built at the east end of the south aisle.

Originally, the tower had three bells, but another three bells were installed in 1892. The church clock face is on the eastern side of the tower.

Most of the church is built from the local Rotherham red sandstone; however, sandstone is prone to weathering and erosion so, when the sandstone structure

began to show signs of wearing, a restoration technique which had been adopted by William Morris, and known as 'Honest Repair', was used at St Helen's. The process used thin layers of stone to fill spaces left in the eroded stone.

The stone font is near to the doorway into the church, symbolising entry into the Christian faith.

Although there are some remains of the earlier box pews to be seen in the wall panelling, the pews in the main body of the church date from Victorian times. The four evangelists are depicted on the reredos on the east wall. The triptych above the altar dates from the nineteenth century. The Pieta triptych on the south wall of the church shows the Virgin Mary holding the body of the crucified Christ.

The chancel arch has a carved wooden screen which leads into the chancel. The organ is on the south wall of the chancel. A 'Green Man' is carved on one of the beams; the 'Green Man' is an ancient symbol which is regarded by many as being a symbol of rebirth.

The church has hagioscopes or 'squints' on either side, which, in former days, allowed lepers a view of the high altar during church services, albeit at a safe distance from the regular congregation.

The church was restored in 1869 and again in 1892.

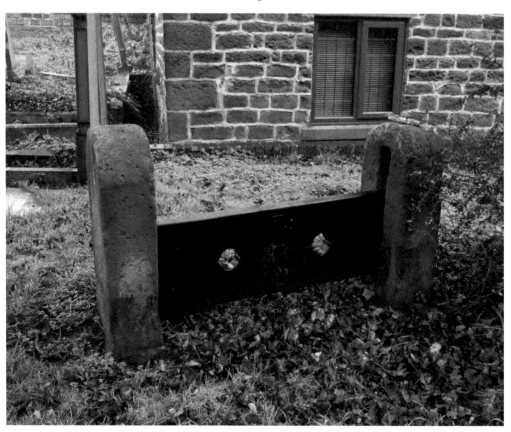

Village stocks still retained in the churchyard.

War memorial.

The owner of the nearby Orgreave Colliery donated the carved marble pulpit in the nineteenth century. Also during the nineteenth-century restorations on the church, a thirteenth-century coffin lid was placed just behind the pulpit.

In 1973 a new vestry was added to the side of the north aisle.

In the churchyard there are the war graves of three service personnel: Serjeant Thomas William Cooper of the York and Lancaster Regiment, who lost his life during the First World War; Aircraftman Reginald Irving Payne, who lost his life during the Second World War; and Able Seaman George Edwards, who also lost his life during the Second World War.

Location: S60 5QP

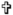

10. TODMORDEN UNITARIAN CHURCH, TODMORDEN

A chapel and school were first built in Todmorden by the Unitarians in 1823.

John Fielden, Member of Parliament for Oldham, mill owner and social reformer, attended and supported the local Unitarian chapel at Todmorden. Fielden had started life as a Quaker, then moved to Methodism and finally to Methodist Unitarianism. Nonconformist Unitarians did not accept the concept of the Holy Trinity, but looked upon God as one being, and Jesus as a prophet.

However, because of the growth in the local Unitarian community, the chapel was becoming too small to accommodate its burgeoning congregation, and it soon became apparent that there was a pressing need for a larger chapel to be built. It was at this time, 1849, that 'Honest' John Fielden, still a prominent member of the congregation, died. His sons Samuel, John Jr. and Joshua decided to build a new, larger church in his memory. The brothers employed the architect John Gibson to design and build the new chapel. Gibson, a noted architect in his own right, had worked under Charles Barry during the rebuilding of the Palace of Westminster, and had also built Dobroyd Castle for John Fielden Jr.

Flying in the face of criticism, Gibson designed the church in the Gothic Revivalist style, a decision which was difficult for Unitarians to accept, being critical of ostentation and ritual. Work started on building the chapel in 1864, but the work was not completed until 1869.

The Todmorden Unitarian Church is still considered to be one of the finest examples of the Gothic Revivalist style of architecture in the North West. Fortunately the Fieldens were a very wealthy family, as the final building costs of the church amounted to six times the original estimates. The final cost of the building amounted to some £35,000.

When the chapel was first opened on Wednesday 7 April 1869, the congregation of 800 listened to an inaugural sermon preached by the widower of novelist Elizabeth Gaskell – William Gaskell – a leading figure in the Unitarian movement in the Manchester area. Looking at the grandeur of some of the fixtures and fittings in the chapel, it was considered by many in the congregation that, apart from the altar, the chapel resembled the layout and design of an Anglican church. Sensing

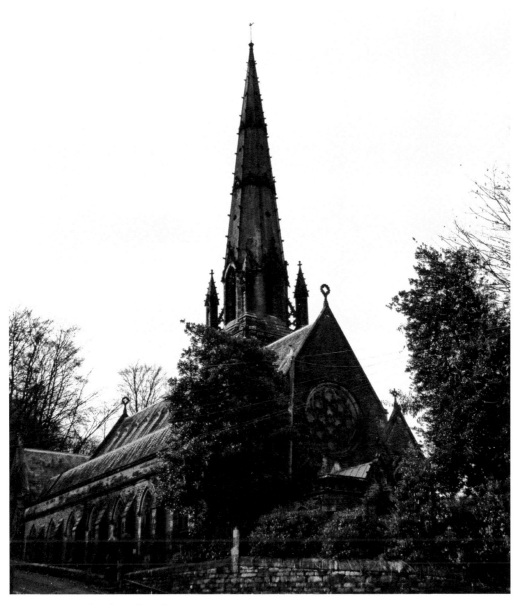

Unitarian church, Todmorden.

this unease at the apparently ostentatious style of the chapel, Gaskell, attempting to appease Gibson's decision, devoted part of his sermon in order to suggest that the judicious use of 'Art' could be an enhancing factor in religious observation.

The church 'footprint' differs from more traditional churches, in that its axis faces the south-west rather than the more conventional east-facing elevation. The church has a seven-bay nave with aisles, a single-bay chancel, a porch and transepts. There is also a tower, together with an octagonal spire which rises to

Five-light east window by Jean-Baptiste Capronnier.

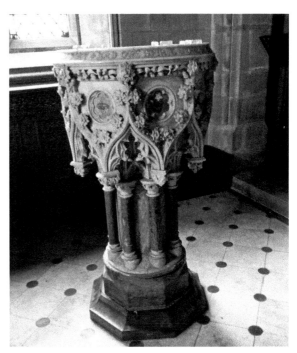

Font bowl carved from a single block of white marble.

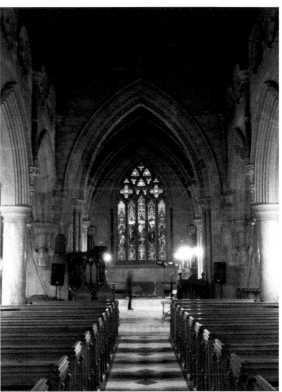

Looking along the nave towards the chancel.

a height of 192 feet. Beneath the pinnacle four figures can be seen, a man, a lion, an ox, and an eagle, symbolising the four evangelists Matthew, Mark, Luke and John. The tower also has a clock and a carillon drum. Mears and Stainbank of the Whitechapel Bell Foundry cast all eight of the church's ring of bells. The full octave of eight bells can be rung either by pull ropes or by using the mechanism of wires and hammers in the carillon drum. The carillon can play four Victorian tunes, amongst which is 'Home Sweet Home'.

The rose window at the west end of the church is reputed to contain in excess of thirty thousand individual pieces of glass. The five-light window at the east end of the church is by the Brussels stained glass artist Jean-Baptiste Capronnier, and shows scenes from the Life of Christ, and includes a number of His parables.

Every one of the one hundred and twenty pews in the main aisle of the church has a different carving on the end panel.

Above: War memorial commemorating the thirty-six members of the church who gave their lives in the First World War.

Left: West end rose window containing in excess of 30,000 individual pieces of glass.

There are carvings of male and female heads at a number of points around the church, emphasising the Unitarian concept of sexual equality.

The font bowl is carved from a single block of white marble.

There remain in the aisles the gas brackets, which have now been converted to electricity. There are candelabras in the choir stalls.

When the William Hill organ was installed in the church, it utilised an underground water-powered air pump. The organ was converted to electrical power in 1939.

The graves of two of the brothers, Samuel and Joshua, can be found just beyond the tower at the church's western corner. There are a number of commemorative plaques in the church for all three of the brothers, together with suitable inscriptions which reflect their differences in character and temperament.

John Fielden's grave can be found in the grounds of the original Unitarian chapel in Wellfield Terrace.

William Hill organ, originally utilising an underground water-powered air pump.

The war memorial, near to the porch door inside the church, commemorates the thirty-six men of the Unitarian Church, Todmorden, who gave their lives in the First World War.

The chapel and its grounds remained the property of the Fielden family until 1882. After that time, an Endowment Trust was set up by the three brothers in order to give a degree of independence from the family. However, due to a number of factors, including a decline in use and a shortage of financial resources, the church was forced to close its doors in 1987. The church subsequently fell into disrepair, but, in 1994, the Historic Chapels Trust acquired the building. Since taking possession of the chapel, the trust has initiated and completed a £1 million repair programme, which included the refurbishment of the interior of the tower and the repair of the clock and carillon. The programme also included the repair of the church roof and stained-glass windows.

Location: OL14 6LE

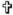

11. ST JAMES' CHURCH, ANSTON

It is recorded in the Domesday Book that the Norman knight Roger de Busli had '10 carucates of land at North Anston, and 6 carucates of land in South Anston' and another Knight, William de Warren, held 'pasturable woodland one furlong in length and half a furlong in breadth; four sokemen and one plough.'

Prior to the Norman invasion, the lands were owned by Edwin, Earl of Mercia, who lived at Laughton, and Earl Harold, who, prior to his death at the Battle of Hastings, was King of England. Sir Roger de Busli and William de Warren were given these lands as a reward for services to William the Conqueror.

The Domesday Book refers to North Anston as being 'Anestan', and South Anston is referred to as 'Litelaston' or 'litelanstone'. At different times, both North Anston and South Anston are given various names, but, as recently as the twentieth century, North Anston is referred to in an official document as 'Chapel Anston' and South Anston is referred to as 'Church Anston'. Many suggestions have been forwarded as to the origin of the name Anston, including 'Anstain' or 'Ana stan', meaning Anna's stone', but the actual origin of the name has been lost in the mists of time.

Official records show that the church of St James was founded in 1174, although there is a deed which dates to 1171 and is signed by Willelmo Clerico de Anestan (William, Clergyman of Anston).

St James' Church follows the Early English style of architecture, having a nave, aisles, and chancel. There is also a square tower which is surmounted by a small spire. The church has a number of monuments to the Lizour, Beauchamp, and D'Arey families.

The nave dates from the twelfth century and is the oldest part of the church. The north aisle was added sometime in the thirteen century, followed by the south

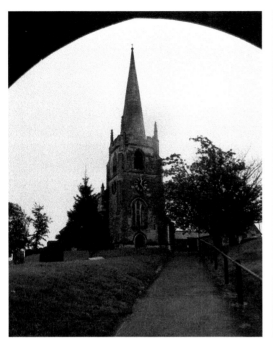

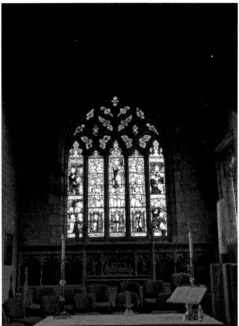

Above left: Church of St James, Anston.

Above right: Chancel and east window.

aisle, which was built in the fourteenth century. The chancel was also built at this time, with the tower being added in the fifteenth century.

For many years the church at South Anston had as its 'mother' church, the church of All Saints, Laughton, which, in effect, meant that until the church at Anston became a church in its own right. Services such as weddings and funerals could not be held there. Because of the distances people had to travel in order to attend these services, coupled with the nature of the terrain, the church assumed the status of chapel-of-ease, and sometime later acquired the sobriquet of 'Chapel Anston'.

There was a great deal of rebuilding which followed the Decorated style of architecture, as can be seen from the buttresses on both sides of the church and the Founder's Tombs on each side of the nave. The clerestory also dates from this period. There is an effigy of an unknown woman and child under the arch of the Founder's Tomb in the north aisle.

In 1866, when civil parishes were created, Woodsetts became a separate civil parish. The remaining part of the parish became the civil parish of North and South Anston.

After an extensive programme of renovation, the church was reopened by the Archbishop of York on 22 November 1886. The work had been carried out under the direction of the architect John Dodsley Webster of Sheffield, working in conjunction with the Restoration Committee. The main contractor for the work

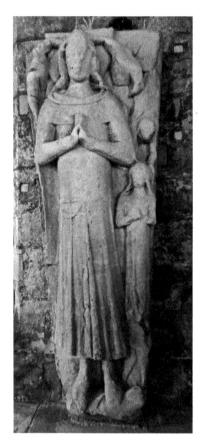

Above left: Fourteenth-century effigy of an adult male with a young girl, thought to be father and daughter.

Above right: Octagonal font.

was Mr William Kirkby of South Anston. Mr Kirkby was responsible for renovating all of the necessary masonry work and woodwork, which included the carving of the oak screen at the west end and the oak choir stalls. All of the box pews were replaced with more practical ones. The north aisle and north chancel walls were rebuilt as they were found to be in an insecure condition; having originally been built of rubble stone, they had no foundations to rest upon. Other work included a new organ chamber and vestry being built at the south side of the chancel. The gallery was also removed, opening out a view at the west end. The west doorway was lowered to its original level, and there is now a new entrance to the church. It was also necessary to replace the roofs of the nave and chancel. A new carved oak pulpit was placed in the church by Mrs Crust, in remembrance of her husband, the late Mr Crust of Beverley. The pulpit was made by Messrs Elwell & Son of Beverley.

Following the archbishop's address, Archdeacon Blakeney appealed to the children of the parish to collect for the restoration of the south aisle porch.

Although much work had been done during the earlier renovations, in 1890 it became necessary to repair the south aisle of the church; Sir Samuel Roberts paid for the work to be done. Also in that year, and following Archdeacon Blakeney's earlier appeal to the children of the parish, enough money had been raised to rebuild the porch. In September 1892 a brass plate was placed in the porch to commemorate this effort by the children.

In March 1871 a peal of six bells was given to the church by George Wright of South Anston and Barnard Platts Broomhead Colton-Fox, a famous solicitor of Sheffield. The bells were cast by John Taylor & Co. at the Loughborough Bell Foundry. When the peal of six bells was rehung in 1928, the tenor bell was also recast. Two further bells were added at this time and dedicated to the memory of Dr. D. M. Clark, sometime churchwarden, and James Turner, Justice of the Peace.

Up until the 1950s, any bell ringer who was late for ringing was required to pay a fine. Fines ranged from 1*d* for being up to five minutes late to 3*d* for being fifteen minutes late. Absence also incurred a fine of 3*d*. The 'fine money' was divided between the bell ringers at the end of the year.

At the age of eighty, Mr. H. M. Turner was still one of the regular band of bell ringers at St James'. Mr Turner was a bell ringer for more than sixty-five years, and a member of the Anston Ringers who held the World Record for ringing more than 200 methods on six bells. The bell ringers of St James had also been the winners of the highly prized Crawford Cup.

A new church organ was built in 1899 by Albert Keates of Sheffield.

Octagonal north side bay pillars.

The stained-glass east windows of the chancel and the stained-glass east window of the north aisle were both donated in memory of members of the Roberts' family.

Mrs Edith Stevenson and Mrs Frances A. Walker, the daughters of Mr James Turner, presented the three stained-glass windows in the apse. The left window, dedicated to the memory of Sarah Mann Turner, wife of James Turner and mother of his children, is a representation of a Mother of Salem bringing her children to Jesus. The centre window, dedicated to the memory of James Turner, JP, shows the appearance of Jesus to the Apostle James after His resurrection, and the window on the right is dedicated to the memory of Mary Gurnell Turner, the second wife of James Turner, and depicts the appearance of Jesus to Mary after His resurrection.

Costing £1,000, a lychgate of dressed stone was erected to the memory of the men of Anston who gave their lives serving in the First World War. The lychgate was opened in 1920 by Mrs Wright of Anston Hall. Then, following the Second World War, service men and women who lost their lives during that war also had their names inscribed on a tablet in the lychgate.

As a result of mining subsidence and general weathering of the stonework, it became necessary in 1969 to strengthen and repoint the walls. The chancel floor was reinforced before being repaved, and a number of the window mullions were replaced before new leaded lights were fitted. Much of the £6,000 cost of the refurbishment was met by the National Coal Board.

Location: S25 5TD

12. ALL SAINTS, DARTON

Darton and its neighbouring village Kexbrough are both included in the Domesday Book as Dertune and Chizeburg, respectively.

Following the founding of Darton in 1150, John de Laci, Earl of Lincoln, and Sir John de Sothill, feudal lords of the manor of Darton, built the first church on the present site. For many years the patronage of the church remained in the hands of the de Laci family, until that is the patronage was transferred to the king, as Duke of Lancaster. However, following a disastrous fire, it is believed that the earlier Norman church, which was a wooden building, was destroyed sometime in the late fifteenth century, and that the monks of the Priory of St Mary Magdalene at Monk Bretton, having been given the living of Darton in 1484 by King Richard III in exchange, it is said, for Holcombe Forest in Lancashire, rebuilt All Saints Church under the direction and auspices of Thomas de Tykell, who was prior of Monk Bretton. The rebuilding, which took about twenty years to complete, is a classic example of the late Perpendicular style of architecture, and was completed in 1517, a fact confirmed by a Latin inscription, which can be seen in the chancel.

The Act of Resumption, which was passed on the accession of Henry VII, appeared to overlook the terms of the exchange, with the king retaining both the

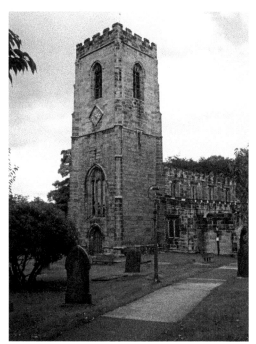

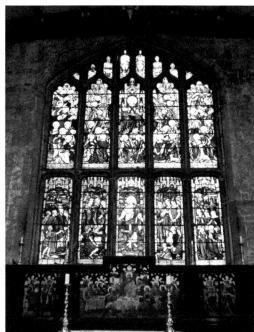

Above left: Church of All Saints, Darton.

Above right: East window.

forest and the patronage of the living of Darton. When a petition was presented to Parliament outlining the facts of the transaction, patronage of the living was duly returned to the priory.

There are a number of cross slabs built into the walls and the floor of the church, which would appear to suggest that the friars recycled gravestones from the churchyard when building the new church. Cross slabs have also been used in both the Beaumont and Silvester Chapels. The rebuilt church was founded by members of the De Laci family, Chief Lords of the Honour of Pontefract and, in essence, there have been no significant structural changes to the church since that time, unlike many other churches of that period.

Over the following centuries the advowson changed on a number of occasions, and towards the end of the eighteenth century the Beaumont family of Bretton Hall gained the patronage, with whom it remained until 1959. At that time the Bishop of Wakefield was given the right of patronage.

The north-west corner is the oldest part of the church and there remains some evidence of an anchorite cell, which was incorporated into the structure by the monks of Monk Bretton Priory. The anchorite cell, or hermits' cell, is where either a man or a woman hermit would, literally, be holed-up, or 'anchored', in the cell; here they would be in complete isolation and would be able to devote the remainder of their lives to prayer and contemplation.

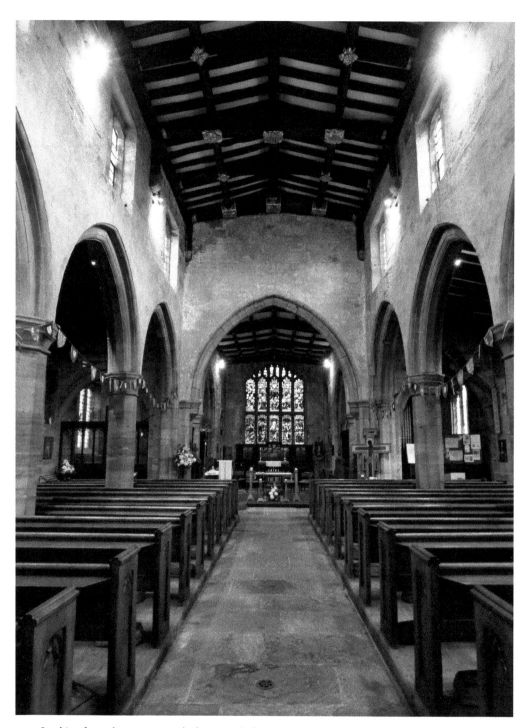

Looking from the nave towards the east window.

The Priory of St Mary Magdalene at Monk Bretton was dissolved on 21 November 1538, in accordance with Henry VIII's Dissolution of the Monasteries.

The tower, together with its original four pinnacles, reached to a height of 80 feet. However, as a result of weathering over the years, it became necessary to remove the pinnacles on grounds of health and safety. When much of the Norman church was being enlarged and reconstructed under the direction of Prior Tykyll, the first phase of the remodelling was the reconstruction of the tower.

The base of the original Norman font is still in the church, although the font itself was donated to St Thomas' Church, Gawber, in 1877 by the vicar of Darton, Revd Charles Sangster, and the churchwardens of All Saints Church.

There are five sister churches in the area which all follow the same architectural style: the churches of Darton, Cawthorne, Royston, High Hoyland and Silkstone.

On the north side of the altar is the Beaumont Chapel, which is often referred to as the Lady Chapel. The chapel has many memorials to members of the Beaumont family. Underneath the altar of the chapel there are five grave slabs commemorating members of the family, with the earliest dating to 1646. What is unusual, however, is the fact that two of the memorials are made of cast iron, a very rare choice of materials at that time.

The oldest stained-glass window in the church is located in the Beaumont chapel, and shows St Mary Magdalene holding the alabaster ointment box. The window was donated by Prior Thomas Tykyll. Originally, the glass had been in the east window, but was replaced by a commemorative window in memory of Joseph Fountain. Although the actual dedication was lost during the transfer, it is thought that it read: 'Pray for the good estate of Thomas Tykyll, Prior of Monk Bretton, and Patron of this church, who caused this window to be made in the year of our Lord 1526.' Examination of the detail in the window reveals five small crosses that are etched into the glass. The crosses represent the Five Wounds of Christ. Also in the chapel, there is a pedimented marble tablet showing a seated cherub at its base.

The original eleventh-century stone altar was replaced during the Reformation by a wooden table, as it was deemed at that time that stone altars symbolised pagan worship and sacrifice. Similarly, frescoes, rood screens, wall paintings, statues and stained-glass windows were all destroyed. However, in 1924, Revd Harold F. Helgood noticed that one of the stones in the churchyard path was slightly out of alignment. In order to make further investigations, he had the stone raised, only to find when it was turned over, that the stone was indeed the eleventh-century Norman altar, which had been displaced during the Reformation. The altar stone was returned to its original position where it now stands. Similar to the crosses etched in the window in the Beaumont chapel, closer inspection of the altar stone reveals five similar crosses chiselled into the surface of the stone, another representation of the Five Wounds of Christ.

The altar is surrounded by the Laudian altar rails, the style of which was introduced when William Laud was Archbishop of Canterbury.

Left: The octagonal font, with seven sides representing the seven days of creation and the eighth side representing new creation in Jesus Christ.

Below: This hand-drawn bier was used until the early twentieth century.

As with many other churches and cathedrals, All Saints Church has a carved imp, but, unlike other churches, the Darton imp is in full view, carved on a pier between the nave and the south aisle at a height of approximately 15 feet.

Depictions of the ubiquitous Green Man, symbolising spring and rebirth, can be seen in the south chapel.

The John Silvester chapel is to be found to the south of the chancel. There is a stately figure of a man who is flanked on either side by seated ladies. One lady looks as though she is comforting children, whereas the other appears to be holding a glove.

A marble monument in the south chapel commemorates John Silvester, Lord of Birthwaite and Kexborough, who died in 1722. By trade John Silvester was a blacksmith at the Tower of London.

Six bells from the Whitechapel foundry were housed in the original oak bell frame, which had been installed in 1759; however, by 1960 the frame had seriously deteriorated and in 1998 it was replaced by a modern steel bell frame. Easter 1999 saw the restoration work completed.

An extremely unfortunate incident occurred at All Saints in 2015, when it became necessary to initiate a criminal investigation. As a result of these investigations, the vicar was accused and subsequently found guilty of stealing £24,000 from the church between 2007 and 2013; monies paid to the church as wedding and funeral fees. Not wanting to face imprisonment, the vicar absconded to Germany, but later returned and handed himself in. He was given a custodial sentence of two years and eight months.

Location: S75 5NQ

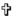

13. ST MARY'S, WORSBROUGH

The parish church of St Mary, Worsbrough, was built during the twelfth century, possibly by some of the masons who built the nearby castle. There is, however, evidence to suggest that there was an earlier foundation on the site dating from Saxon times. Towards the eastern end of the church there is stonework which has been identified as Saxon in origin. In the eastern and northern part of the chancel there is stonework dating to the early Norman period. At one time, a Saxon cross stood to the north of the church, near to a well where four tracks crossed. It is thought that Helliwell Hill (Holy Well) has been a place of some significance for over a thousand years.

Although there is some uncertainty as to the founders of the church, speculation would suggest that it could well have been the Rockley family, who lived in the nearby Rockley Old Hall. It is recorded that in 1412 Sir Robert de Rockley established a private chantry chapel on this site, and there are many memorials to the family in the church.

Some thirty years after being built, the church was extended and shortly after that the south and north aisles were added. The transepts and chantry chapels were built in the south aisle in 1450. Several significant alterations were also made

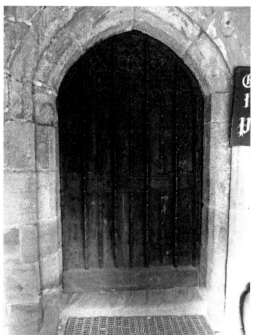

Above left: Church of St Mary, Worsbrough.

Above right: Ancient south door.

to the church during the fourteenth and fifteenth centuries, including the installing in 1480 of the magnificent porch door, an example of the best of that century's craftsmanship. Carved in Gothic relief lettering is the inscription 'IHS NICOLAS GENN + THOMAS ALOTT', both of whom were wardens of the church at that time.

During the English Civil War, 1642–51, the church served as a base for Parliamentarian troops and, as a result, was severely damaged. The north aisle of the church and the quire were both destroyed, although the north aisle was rebuilt later. The church's stained-glass windows were also victims of the Civil War. The windows were replaced in the nineteenth and twentieth centuries.

The church has a four-bay aisled nave together with a south porch, a single-bay chancel and south vestry. St Mary's tower was not built until the eighteenth century. The clock on the church tower has two faces, one which is diamond in shape, and the other is octagonal. There are three bells in the tower; the oldest was cast in 1590 by Henry Dand who was a foreman founder at the Nottingham bell foundry of the Oldfield's between 1558 and 1598. The other two bells were cast in 1797 and 1800 respectively by Thomas Hilton of Wath-on-Dearne.

The church was completely remodelled in 1838 under the direction of the celebrated architect James Pigott Pritchett, who followed the Later English style of architecture.

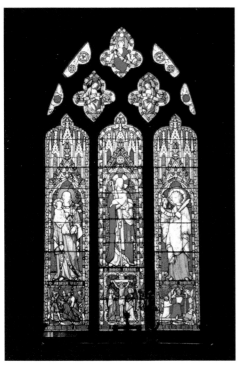

Above left: East window.

Above right: Octagonal font with Gothic side panels.

There is a painted board in the south chapel to John Rayne. The board was enlarged and repainted in 1684.

To the south of the tower arch there is an unusual window depicting Adam and Eve.

There is a poignant memorial in the south chapel, the Lady Chapel, commemorating H. and T. Edmunds, two brothers who died on the same day, Friday 22 March 1709.

In the north-west corner of the nave there is the only remaining box pew of the Elmhurst family, which was installed sometime in the 1730s.

The traditionally styled octagonal font has Gothic side panels and dates from 1662. There is a wall monument over the font to Elizabeth Carrington.

Throughout the church there are several monuments to members of the Rockley family, but perhaps the finest is the freestanding wooden double-decker monument to Sir Roger Rockley, which is to be found between the chancel and south chapel. There are two effigies of Sir Roger, both carved in oak. The upper effigy shows a painted figure of Sir Roger in full armour, whereas the lower effigy depicts Sir Roger as a decomposing cadaver.

In the lower churchyard there is an unmarked grave in which the seventy-five miners who were killed in the Darley Main Pit disaster of Wednesday 24 January

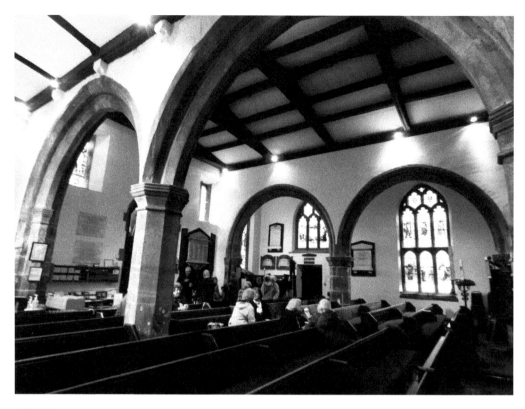

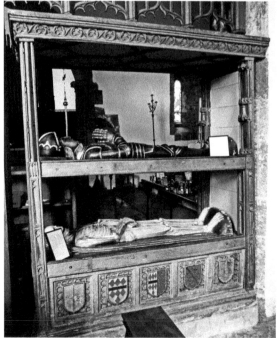

Above: Octagonal pillars on the south side and round pillars on the north side.

Left: Wooden double-decker monument to Sir Roger Rockley.

1849 are buried. (A picture of the funeral scene, which was printed in the *Illustrated London News*, has been retained in the church.)

Location: S70 5LQ

14. ALL SOULS, HALIFAX

The Victorian industrialist and philanthropist Edward Akroyd commissioned and paid for the church of All Souls, Halifax, in 1856. It had become apparent to him that the fast-growing community did not have a local church or a burial ground. In order to remedy the situation, he purchased a former Baptist chapel at Haley Hill in 1854 and had it licensed for Church of England services. In 1855 the [arish of All Souls, Halifax, came into being.

A number of architects were invited to submit designs for the church to Akroyd, and from these designs, he awarded Sir George Gilbert Scott the commission to design and oversee the building of the church. Work started on the building in 1856.

It was widely reported that, had Scott been aware of the amount that Akroyd was prepared to spend on the project, then he would have 'made a better show'. In the event, the building costs amounted to somewhere in the region of £100,000. The church was designed to make a statement, having accommodation for a congregation of some 800 worshipers.

Provision for a burial ground and a mortuary was made a short distance from the church. Edward and his brother Henry also had a memorial chapel built in memory of their father Jonathan, the corner stone of which was laid on 21 April 1855, just over a year before the laying of the new church's foundation stone.

It was rumoured, although never proved, that the site for the church had been chosen such that it blocked the view of the Nonconformist Square Congregational Church from Akroyd's home at Bankfield.

On Friday 25 April 1856 there was a grand ceremony, which marked the laying of the foundation stone. A leaden box was placed under the stone at the north-east corner of the building. The box contained a set of coins from 1856, a document which described the elaborate ceremony and a brass plate with a suitable inscription.

Progress on the construction of the church was interrupted for a little while because of the discovery of a mine shaft directly beneath the site of the church. The discovery necessitated the foundations having to be somewhat deeper than originally envisaged.

The building was completed in 1859 under the watchful eye of the church's architect, Sir George Gilbert Scott, who considered it to be his finest achievement. The church was intended to be the centrepiece of the model village, Akroydon, which was also designed by Scott.

The Right Reverend Robert Bickersteth, the Lord Bishop of Ripon, consecrated the church on 2 November 1859, All Souls Day.

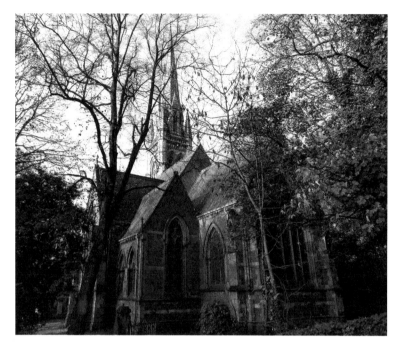

Left: Church of
All Souls, Halifax.

Below left: Great
west door, All
Souls.

Below right: All
Souls spire.

The architectural style of the church follows the contemporary style of the early fourteenth century. The church has a nave with clerestory, north and south aisles, north and south transepts, a chancel with chapels to the north and south, and a south porch.

The clerestory has fifteen windows on either side. Built into the walls of the chancel are a sedilia and a credence table. The reredos is alabaster and has a number of niches with statues which include the Virgin Mary, Mary Magdalene, Nicodemus and Joseph of Arimathea. Made from Caen stone, the octagonal pulpit stands on a pedestal of Derbyshire marble. The square font has a circular bowl and is made from lizardite serpentine. The font is mounted on a pedestal of red Aberdeen granite.

The windows, which all feature stained glass, were manufactured by Hardman & Co., William Wailes, and Clayton & Bell. The west window, which is a depiction of the Last Judgement, was donated to the church by Edward Akroyd's brother Harry in 1859.

The original organ was installed when the church itself was consecrated. The current organ, which is in need of restoration, was built in 1868 by Forster and Andrews of Hull to a specification by Edmund Schultze. In 1902 the organ was rebuilt and enlarged by Norman and Beard, the pipe organ builders of Norwich. The organ was restored in 1969 by J. W. Walker & Sons. Sometime later the organ suffered from vandalism, and the decision was taken to hold the remaining pipes in storage for safekeeping.

 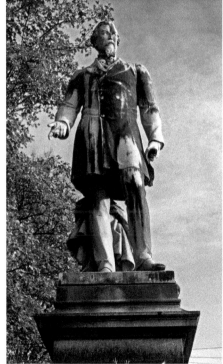

Above left: South porch.

Above right: Edward Akroyd, politician and textile manufacturer.

The ring of eight bells was cast in 1859 by G. Mears at the Whitechapel Bell Foundry in London.

The tower is 236 feet high, the second highest in the county after Wakefield Cathedral.

The church had been built from a combination of sandstone and limestone. But chemical reaction from rainwater running off from the limestone caused erosion of the sandstone and, ultimately, led to the structure becoming unsafe. When significant damage was caused in 1977 due to falling masonry, the Parochial Church Council decided that, on grounds of health and safety, the church needed to be closed. This happened in 1978.

A grant of £260,000 was awarded by the National Heritage Memorial Fund in 1982. Renovations were made to the tower and spire and were completed in 1985.

On 1 March 1979 the church was declared redundant and was vested in the Churches Conservation Trust on 2 August 1989.

Location: HX3 6DR

15. ST MARY'S, TICKHILL

In Anglo-Saxon times, Tickhill was known as Dadesley. The Domesday Book does not record that there was a church at Dadesley, although it is thought that there was a pre-Norman church on the site.

Following the Conquest, the Norman Roger de Busli became tenant-in-chief of Tickhill and was awarded forty-six other manors in Yorkshire, in addition to many more in Nottinghamshire and Derbyshire. After his death and many other changes of ownership over the following centuries, Roger de Laci, Lord of Pontefract, ultimately assumed possession.

In plan, the church includes a nave, chancel, and side aisles and there is a tower at the west end together with a clock and chimes.

The second church at Tickhill appears to have been built sometime in the twelfth century, the end of the Transitional Norman period. The dedication of St Mary's was granted to the Canons of St Oswald of Nostell by Thurstan, Archbishop of York, and later confirmed by charter by Henry I. Prior to the tower being extended in height, it would have exhibited a more fortress-like appearance.

A chapel was built beside the chancel in the early part of the fourteenth century sometime before any major rebuilding work had begun. This, effectively, meant that the north wall of the chancel, from being an outside wall, now became a wall on the inside of the church.

The doorway from the chancel to the chapel would tend to indicate that there was a priests' vestry on the north side of the chancel before the chapel had been added.

The wife of Adam de Herthill of Tickhill, Amicia, founded the chapel, which later became associated with the chantry of St Helen. Before assuming the name of the Laughton chapel in the eighteenth century, owing to the Laughton family living

at Eastfield, the chapel had been known as the Eastfield chapel. After renovation at the end of the twentieth century, the chapel was rededicated as St Helen's chapel.

There is a distinct possibility that William de Estfield, together with a number of merchants from the immediate vicinity, were instrumental in building the present church of St Mary; a church which closely follows the Perpendicular style of architecture.

An altar tomb to William de Estfield, Seneschal of Holderness and the Honour of Tickhill, who died in 1386, is in the chancel on the north side of the altar. There is also a brass memorial plate on the wall above.

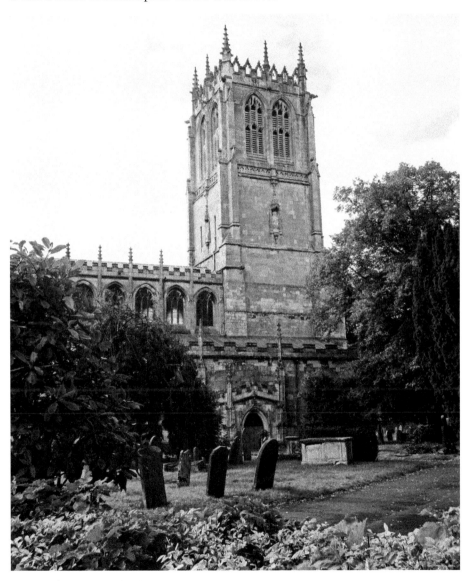

Church of St Mary, Tickhill.

Above left: Ancient sundial over porch entrance.

Above right: Rare cast-iron pew-end finials.

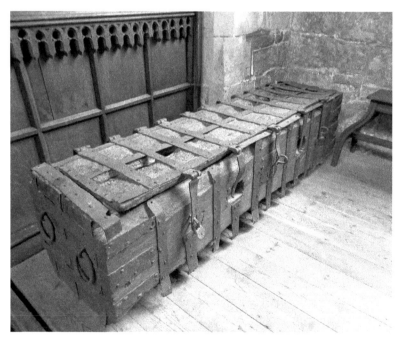

Secure elm
parish chest
made in 1500.

There were significant changes made to the church between 1370 and 1440. During this period, the aisles were made wider, a window was inserted above the chancel arch and a new window was introduced above the altar at the east end of the chancel. A new west window was also inserted above the west door, porches were added to the north and south doors, and a clerestory was built having eight windows to north and eight to the south.

A carved Roche Abbey stone slab on the south of the altar is a memorial to John Sandford, who died in 1429.

A marble monument, the Fitzwilliam tomb, at the west end of the north aisle is said to have been brought from St Augustine's Priory following the Dissolution of the Monasteries in 1538, when it was removed from Tickhill Friary church and moved to St Mary's parish church. The monument commemorates Sir Richard FitzWilliam, who died on 2 September 1478, and Elizabeth Clarel, his wife, who died on 12 May 1496. The monument also commemorates their son Sir Thomas Fitzwilliam and his wife Lady Lucy Neville.

The effigies on the Fitzwilliam tomb are those of Sir Thomas Fitzwilliam and Lucy Neville. Originally sited in the south-east corner of the church, the tomb was moved to the north-west corner and placed behind railings in the nineteenth century. Over the years, the tomb had deteriorated as a result of damp and some malicious damage, which had been caused during the Civil War. As a result of the restoration programme, which started in 2012, the tomb was completely rebuilt, the bones were reinterred in 2013, and in March the following year, the restored alabaster panels were replaced. The tomb was also moved to its present location.

On 14 December 1825, the church was struck by lightning, which caused extensive damage. Substantial repairs had to be made inside the church, and it became necessary to re-roof the church the following year.

The west window and the two aisle stained-glass windows to the west were inserted due to the beneficence of the Misses Alderson, great aunts of a former vicar.

The Foljambe Tomb with the sculpted effigy of the twenty-nine-year-old Louisa Blanche Foljambe with her baby son is to be seen in the north-west corner of St Mary's Church.

At St Mary's the worship was led by a group of minstrels who occupied a gallery situated at the west end of the church. However, this changed in 1831 when St Mary's introduced a 'finger' organ. Further changes were made in 1857 when Charles Brindley of Brindley & Foster, the organ builders of Sheffield, built St Mary's first pipe organ. In 1896 the organ was rebuilt and repositioned by Brindley and Foster and subsequently moved to the north chapel – the Laughton Chapel, or St Helen's Chapel as it is now known. A descendant of the Laughton family, Mrs Curtis, donated a new oak case for the organ. The organ was moved again in 1937 when Wood Wordsworth of Leeds was commissioned to reposition the organ behind the choir on the south side of the chancel. Then, because of its poor condition, in 1965 the London organ builders J. W. Walker & Sons Ltd was commissioned to rebuild the instrument. The total cost of the work amounted to £4,409.

St Mary's has a peal of eight bells weighing 3.5 tons. It is recorded on the peal board in the tower that, on 19 December 1863, a peal of 5,040 changes were rung – the first ever at Tickhill. The peal took two hours and fifty minutes.

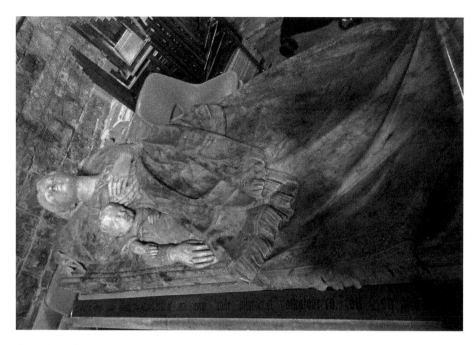

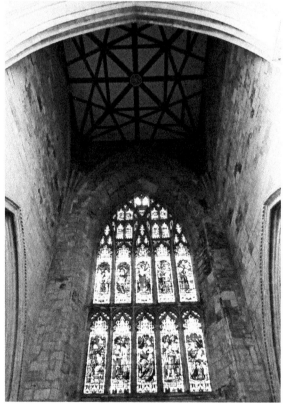

Above: The Foljambe Tomb, with the sculpted effigy of Louisa Blanche Foljambe with her baby son.

Left: West window.

Up until the time of Queen Victoria's Diamond Jubilee in 1897 the church had six bells, the oldest of which had been cast in 1726. In 1896 the original six bells were retuned at the foundry of John Taylor & Co at Loughborough and two new bells were cast. To celebrate the Queen's Diamond Jubilee a local benefactor had a carillon installed when the bells were rehung. The carillon rings a different tune every four hours. On 24 February 1897 the bells were dedicated by the Bishop of Beverley, with the ringers, choir and churchwardens in attendance.

Location: DN11 9LY

16. All Saints, Aston cum Aughton

There was a village at Aston in Anglo-Saxon times, as the village is recorded as Estone in the Domesday Book. The name itself is derived from the old English word East-Tun, meaning an enclosure or a homestead in the east. There is a distinct possibility that, similar to other villages in the area, there was a wooden church at Aston in pre-Norman times. What is, however, recorded in the Domesday Book is the fact that, at the time of the survey, there was a church and a priest at Aston. Little remains of the original Anglo-Saxon church save for the ancient altar stone. The present church was built towards the end of the twelfth century, but had major remodelling during the fourteenth and fifteenth centuries. Also, the chancel was rebuilt during the nineteenth century.

Until the time of the Reformation of the Church in England, the Melton family were the patrons of the living at Aston cum Aughton, a period spanning more

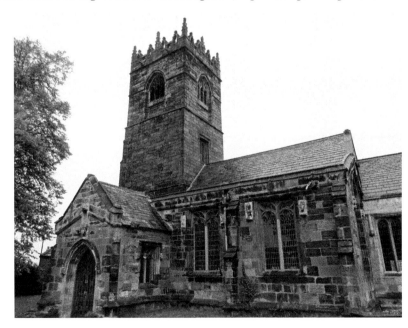

Church of All Saints, Aston cum Aughton.

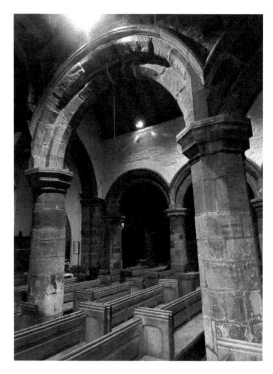

Alternate rounded and octagonal bay pillars.

than two hundred years from 1332 until 1539. A tomb of the Melton family is set into the floor of the chancel.

A number of different styles of architecture are visible in the church, suggesting that it was altered and/or enlarged over a sustained period. The nave has five Norman and one Gothic arch, the pillars being, alternately, rounded and octagonal, whereas the transepts date from the Decorated period, and the tower follows the Perpendicular style of architecture. The south porch, which follows the Decorated style of architecture, was built during the fourteenth century. The heads of Edward III and Queen Philippa can be seen on the corbels of the outer doorway, although over time, due to deterioration by chemical pollution, much of the detail has been lost.

Towards the base of the tower there is what was a 'Leper's Window' or 'squint'. The 'squint' or, more correctly, the hagioscope allowed sufferers from leprosy, who were not allowed in the church, a view of the elevation of the Host during the Sacrament, albeit at a safe distance from the regular congregation. The window has now been blocked up.

The Perpendicular octagonal font in the south aisle, which dates to the beginning of the fifteenth century, is unusual in that there is on its base a carved figure of King Herod together with a dagger in his hand, apparently lying in wait for the Infant Christ, whereas on the opposite side is a watching angel.

In the centre of the east window of the south aisle is the D'Arcy arms surrounded by the arms of other prominent families of the area. Formerly beneath this window there was the altar of the chapel of St Mary. The piscina still remains.

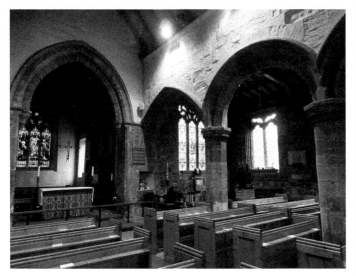

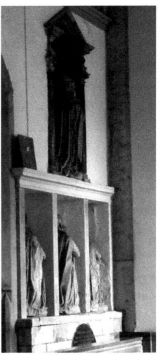

Above: Nave with five Norman and one Gothic arch.

Right: Kneeling alabaster figures on the north wall.

Four kneeling alabaster figures are to be found in four niches on the north wall. The first effigy is of John, Lord D'Arcy, and the three other figures are those of three of his four wives. Local tradition asserts that his first wife was married for her beauty, the second for her wealth and the third for love. Sir John's fourth wife outlived him, and her monument can be seen on the opposite wall directly under the crest of her second husband, Sir Francis Fane.

The leaded windows of the north aisle are plain glass. There are some ancient engraved brasses beneath one of the north windows. One of the plates is in commemoration of the life of Sir John Melton. The Melton coats of arms are engraved on two smaller shields.

The beginning of the eighteenth century saw a gallery being erected beneath the bell chamber at the west end of the church. The gallery was filled with seats which had to be paid for, so, more often than not, they were occupied by the church's more affluent parishioners.

Sometime in the nineteenth century the gallery ceased to be used for seating, and a barrel organ was installed in the space. The story is still told locally of the day when the organ stopped halfway through a hymn. Some minutes later, after an embarrassingly long pause in proceedings, a somewhat sheepish-looking handle-turner appeared and informed the rector and the assembled congregation that 'T'andle's cum off!'

There was a survey in 1552 that verified that there were three bells at All Saints. In former times the bells were rung at six in the morning and also at noon on weekdays, and at seven in the morning on Sundays, but this practice has now

ceased. The present bells were placed in the tower during the incumbency of Revd William Mason, who was rector from 1755 to 1797. The bells were cast by Walker & Hilton of Rotheram.

Revd Christopher Alderson, who succeeded William Mason as rector of Aston, had a memorial tablet to his predecessor placed on the north wall of the chancel. The memorial commemorates Rector William Mason and his friend Thomas Gray, who wrote *Elegy in a Country Churchyard*.

When the chancel was being refurbished, the ancient altar stone which had been discovered was restored in its central position. It is possible that the large altar stone, almost 7 feet in length, is a relic from the original Saxon church on the site, although there is no documentary evidence to verify this. Also, during the time of the refurbishment of the chancel, the wooden tablets upon which were written the Ten Commandments were removed from their location on either side of the east window on the south wall.

When plaster was removed from the walls of the church, two passages of scripture were uncovered on the north wall. The inscriptions date from Reformation times, when it was forbidden to have paintings on the walls, although passages of scripture were allowed. Also on the north wall there is a marble bas relief of the Virgin and Child, dating from 1855, by the Italian sculptor Giovanni Bastianini.

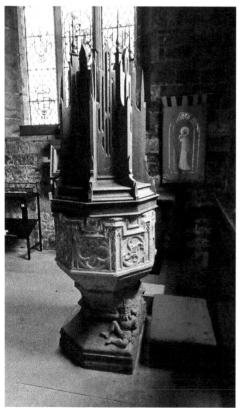

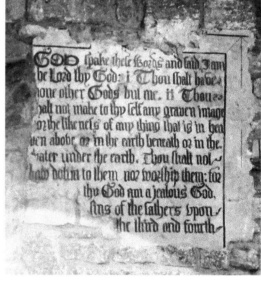

Above: Passage of scripture on the north wall.

Left: Octagonal font in the south aisle, dating to the fifteenth century.

There is an oak eagle lectern which is overlaid in gold leaf. The lectern is dedicated to the memory of Revd W. H. Brooke, who was rector of Aston from 1909 to 1938.

Shortly after the end of the First World War the area directly under the belfry, which was formerly used as additional seating when required, was reordered as a war memorial, and incorporated a carved oak screen together with a brass plate which commemorated all the men of Aston parish who lost their lives during the First World War. The war memorial now commemorates men and women who gave their lives during both world wars. Nearby, there is a record of men who have served as rectors of Aston. The first name on the list dates from 1254.

A number of carvings on the outside of the south transept walls were testament to the church's mission of keeping at bay or driving out the works of the Evil One.

Location: S26 2AX

☦

17. All Saints, Darfield

The wooden Saxon church that originally occupied this site was built in the eighth century and the name, Darfield, also derives from that time; 'feld' is a Saxon word meaning an area of pasture and 'dere' alludes to the fact that there were deer in the vicinity. Darfield is a corruption of the word 'Derefeld'.

The lower section of the Norman tower is the oldest part of the present building, with the nave, chancel and south aisle all being built during the fourteenth century. The north aisle, clergy vestry, porch and the upper part of the tower were all added in the fifteenth century with very little subsequent change to the fundamental structure of the church. There was, however, a small extension to the church in 1905. Some restoration was carried out later in the century in order to compensate for mining subsidence.

Security of the church is maintained by the solid oak bar which can be drawn across the door, thus negating the need for a more conventional lock.

The east window, which was dedicated in 1915, has depictions which illustrate the spread of Christianity in north of England through the saints of Saxon times.

Dominating the baptistery is the carved medieval stone font, together with its Jacobean oak cover, which gives a representation of the tongues of fire of the Holy Spirit at the first Pentecost. The nearby baptistery window was donated by members of the Mothers Union in thanksgiving for the safe return of parishioners at the end of the First World War.

Many of the chairs and kneelers in the south chapel have been placed there in memory of loved ones or to mark family anniversaries. The memorials on the walls commemorate those who gave their lives in the two world wars.

In the north aisle is the Good Samaritan window. Originally, there was a north doorway here, which allowed direct access to the church for processions to move through the church unimpeded. Blocked up for many years, but rediscovered

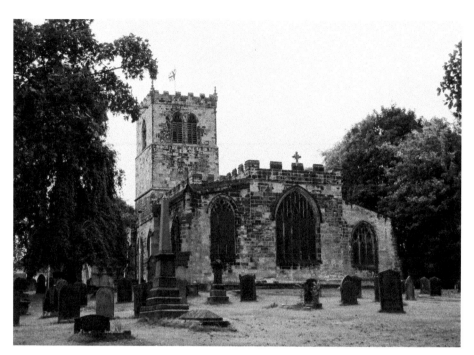

Church of All Saints, Darfield.

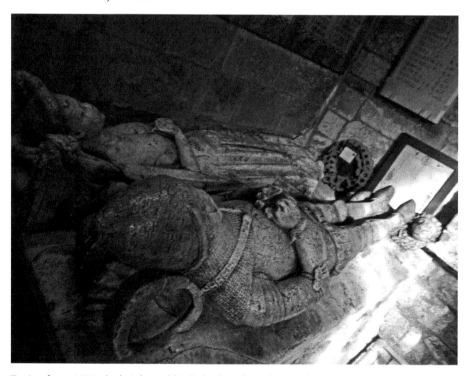

Dating from 1400, the knight and his lady, thought to be members of the Bosville family.

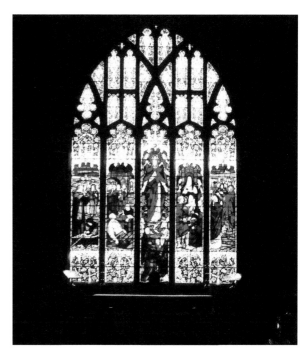

Right: East window.

Below: Family box pew.

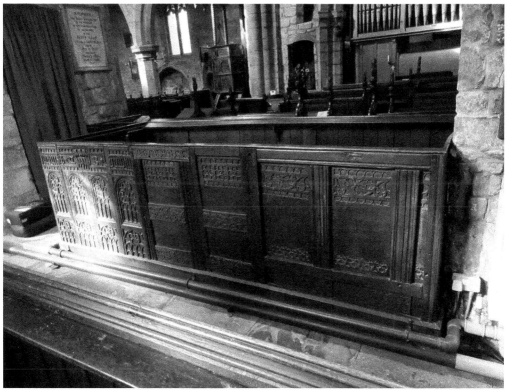

during the 1911 restorations in the church, the window now celebrates this restoration.

The stained-glass windows in the south aisle are memorials to members of the Sorby family. There is the memorial window, dedicated to the memory of Lieutenant Charles Malin Clifton Sorby, who was killed in action near to Ypres on 8 May 1915. The window, depicting St George and St Louis, was donated by his parents Revd Albert Ernest Sorby, rector of Darfield, and Lydia Jane Sorby and was dedicated on 3 June 1916. His wartime grave, a wooden cross, hangs on the wall nearby.

The other window, the Ascension window, is dedicated to the memory of Canon Albert Ernest Sorby, and was unveiled and dedicated on Wednesday 21 December 1938 by the Bishop of Sheffield. The window shows a picture of Christ ascending into Heaven and was erected by public subscription in tribute to and recognition of forty-two years of faithful ministration as parish priest of Darfield parish church, from 1892 to his death in 1934. During that time, Canon Sorby did much to beautify the church, for which he had a deep love, but perhaps his most notable achievement was his triumph in having established, through the High Courts, the right to withdraw children from school for religious instruction on Ascension Day. The bishop also referred to another of Canon Sorby's achievements which took place during the General Strike of 1926, when he successfully organised workshops for striking miners from the district in the carving of a magnificent oak chancel screen.

In April 1898 Mr Francis Howard Taylor of Middlewood Hall donated the church's clock mechanism. In 1977 the clock's winding apparatus was modified so that it could be powered by electricity.

Makin digital organ installed in 2009.

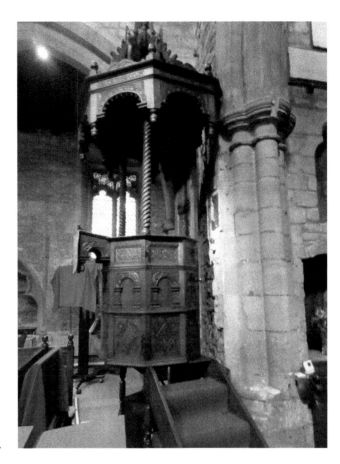

The canopied pulpit,
given by Canon Sorby in
memory of his son-in-law.

The Jacobean box pews date from the seventeenth century. During the
nineteenth century free pews were available for less well-off parishioners in the
galleries and at the sides of the church, but more affluent worshippers could rent a
regular pew of their choosing. A brass plate affixed to the end of the pew indicated
the family to whom the pew had been rented.

In 1897 the screen between the chancel and the Lady Chapel, which was
originally between the chancel and the nave, was carved at the rectory.

In the Middle Ages, what is now the Lady Chapel was a chantry chapel, with the
priest's door in the south wall giving access for the priest to pray for the chapel's
benefactors. The alabaster figures in the chapel of a knight and a lady date from
the beginning of the fifteenth century and are, in all probability, members of the
Bosville family.

The original church organ was installed in 1882, and the organ pipes of that
organ can still be seen. However, because of water damage to the organ as a result
of roof lead being stolen, a Makin digital organ was installed in 2009.

Like many other churches of the period All Saints has a large medieval chest
in which church vestments, silver, records and documents relating to the seven
villages within the parish would be kept. As such, the chest had seven locks along

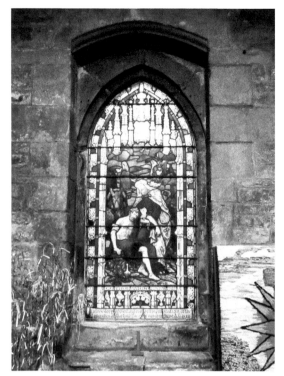

Above left: The Good Samaritan window.

Above right: Memorial to the 189 men and boys who were killed in the Lundhill Colliery disaster of 19 February 1857.

its length, which meant that the chest could only be opened in the presence of all seven key holders.

Originally there was a peal of six bells at All Saints, Darfield, but this was augmented to eight bells in 1979. The most recent bell to be cast is in fact the number one bell, which was cast in 1979 at the Royal Eijsbouts bell foundry in Holland. Mr Bryan, a member of the parish who donated the bell, had it cast in memory of his wife, Sarah.

The second bell came from the now redundant church of All Saints, Moss. In 1978 the bell was removed to All Saints, Darfield, and subsequently recast at Eijsbouts foundry. The frieze around both bells shows children playing, as both bells were cast in 'the year of the child'.

Bell number three, for many years the treble bell of the old ring of six, was cast in 1780 by a local bell founder, Thomas Hilton of Wath-upon-Dearne. The fourth bell is dated 1675 and was cast by Samuel Smith Snr of York.

The fifth and sixth bells have no marks relating to their date of casting, but are thought to be the oldest bells in the tower, and were probably cast sometime before the Reformation. Local folklore suggests that both bells originally hung in Beauchief Abbey near Sheffield, but this is, at best, supposition.

Bell number seven was cast in 1750 by J. Ludlam and A. Walker of Rotherham. The founder of bell number eight is not known, but what is known is that the bell bears the inscription: 'All men that heare my mournful sound repent before you lye in ground. 1613.'

An obelisk near to the eastern wall of the churchyard marks the final resting place of 146 men and boys of the 189 who were killed at Wombwell in the Lundhill Colliery firedamp (methane gas) explosion of 19 February 1857.

There is another monument in the churchyard, erected to mark the tragic loss of ten miners at Houghton Main Colliery on 30 December 1886 when, it is thought, the cage was over wound and went into the head frame, causing the winding rope to break, which resulted in the cage falling to the bottom of the shaft, killing all ten miners who were in the cage.

Also in the graveyard is the grave of Ebenezer Elliott who, in 1846, played a prominent role in the campaign for the repeal of the Corn Laws.

Location: S73 9JX

✠

18. ALL HALLOWS, ALMONDBURY

Reference is made to the ancient settlement of Almondbury in the Domesday Book. The lands in and around Almondbury – listed as Almaneberie in the survey – were awarded to Ilbert de Laci by William the Conqueror.

Two Anglo-Saxon grave slabs, which can be seen in the graveyard, would indicate that there was a church on this site before Norman times. A third slab forms the header to an opening in the tower. Although there is recorded evidence that there was a church on this site as early as 1231, it is a commonly held belief that, prior to this, there was a smaller church on the site. The twelfth-century lancet windows, which can be seen in the north and south walls of the chancel, would also give credence to there being an earlier church, possibly having been built by the old Norman de Laci family.

All Hallows still retains a written record of the institution of a rector of Almondbury from the twelfth century, and some elements of its mediaeval foundation are still evident, although the current church dates mainly from the fifteenth century and was not completed, with its unique ceiling, until early in the sixteenth century. Further reordering occurred during the nineteenth century. In more recent times, two of the fifteenth-century stained-glass windows have been undergoing conservation and the church has been completely re-roofed.

Much of the fabric of the present church dates from the building period between 1470 and 1520. The building work started with the nave and progressed to the aisles and then to the tower. The five-stage square tower at All Hallows stands some 70 feet high. The tower clock, which has faces on the north and east sides, was made and installed by the renowned clockmaker Titus Bancroft of Sowerby Bridge at a cost of £250. It was necessary to wind the clock every three days, until that is the mechanism was electrified in 1977.

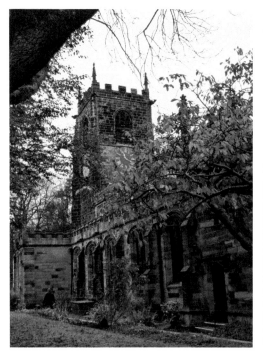
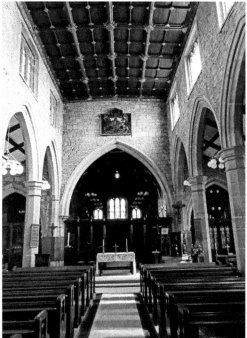

Above left: Church of All Hallows, Almondbury.

Above right: Looking towards the east window.

The north and south chapels were, in all probability, founded by two of the leading families of the area, the Kayes' and the Beaumonts' as chantry chapels. An oak screen separated the main body of the church, the nave, from the chancel.

In the reign of Edward VI all of the seating in the church, which comprised a number of stools and a series of forms, were replaced by more conventional pews; the costs of installation was met by members of the Kaye family. As Almondbury was a relatively large parish, the seating arrangements were then divided into a number of specific areas; seating for parishioners from Almondbury and Crosland was located in the centre, Honley, Farnley and Meltham sat towards the north, whereas the Holmfirth pews were located in the south.

Having lost the rood figures during the religious turmoil of the sixteenth and seventeenth centuries, the figures were replaced by a family pew built specifically for the Kaye family of Woodsome Hall.

The work on the nave, which had been started in 1470, continued at a steady pace, and, over the lengthy period of construction, the architectural style transitioned from the Early English style to that of the Perpendicular style and, although there were changes made in the nineteenth century, the church still retains its Perpendicular characteristics.

In 1870, some three years after Revd Charles Augustus Hulbert assumed the incumbency of the parish, it was decided that major renovations were needed

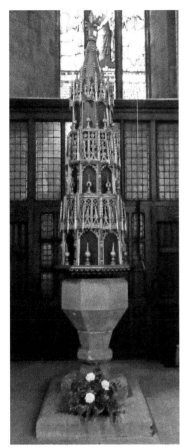

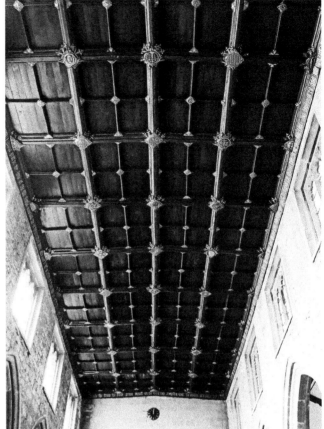

Above left: Octagonal font with 10-foot-high Tudor cover.

Above right: Painted oak ceiling.

at the church. With a phased programme of work being agreed, work on the restoration started in September 1872.

A new porch was built to replace the existing one and changes were made to the nave and the churchyard. Internally, the church was re-pewed and refloored with tiles being laid over the stone flags.

With the first phase of the ambitious programme being completed some eighteen months later, a service of thanksgiving was held in the restored church building. Phase two of the programme started shortly afterwards, the main focus being to restore the chancel. This work was completed towards the end of 1876. The completion costs for the programme of restoration amounted to £8,500.

All Hallows has a ring of eight bells. In 1890 the organ builders Abbott and Smith of Leeds built and installed a three-manual organ at All Hallows. In 1970 the organ was rebuilt and enlarged by the pipe organ builders Wood of Huddersfield with a new detached console and extensive new pipework being

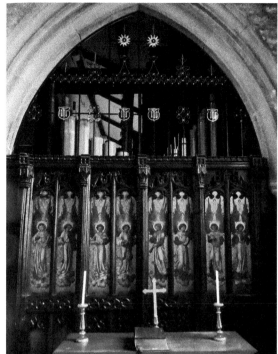

Above left: Pulpit given in memory of Revd Lewis Jones, vicar from 1824 to 1867.

Above right: Screen of angels, painted by the Victorian artist A. O. Hemming.

added. The company was re-engaged in 1999 to make some further modifications when the console was turned through 90 degrees and the great and choir organs relocated. The oak screen was carved by Richard Burrows.

The church was refurbished in 1936/37 under the direction of the English architect Sir Charles Archibald Nicholson, the work being necessitated by death watch beetle having rotted the roof timbers.

All Hallows has a garden of remembrance in the closed graveyard.

Location: HD5 8XF

19. St Peter's, Conisbrough

St Peter's is thought to be the oldest building in South Yorkshire, dating to the Saxon era and sharing many similarities with a number of verified eighth-century churches in Northumbria. The church still retains evidence and remains of an Anglo-Saxon minster church. At the time of the Domesday Book in 1086, Conisbrough had a unique position, in that the Lordship of Conisbrough included

some twenty-eight townships throughout south Yorkshire. Many of the towns' churches looked to St Peter's as being their mother church. The Domesday Book made reference to the fact that there was a church and a priest at Conisbrough.

After the Norman Conquest, it is recorded that the influential Warenne family owned the Conisbrough estate, and had the patronage of the church and priest. In 1121 the family gave the church of St Peter to the medieval Cluniac priory in Lewes, East Sussex, who, in turn, gave the living of Conisbrough to the papal chancellor in England. This situation remained until the Dissolution of the Monasteries.

The church is believed to have had a chancel, a western tower and a nave with porches to both the north and south; the oldest parts of the church are the nave and the lower levels of the west tower.

As the population of Conisbrough grew during the twelfth century there was some remodelling to the building when aisles were added to the body of the church. The chancel was extended sometime in the fifteenth century. Also during this time the tower was raised and refaced and a clerestory was added. Windows were also inserted in the nave and chancel. Still to be seen in the at the west end of the north aisle are fragments of medieval stained glass. The roundels depict biblical figures from the Old Testament. One depicts Prior Atwell of Lewes and the other, 'Our Lady of Pity'.

The aisles and the chancel arch were added during the twelfth century, as were the south door and the tomb chest in the south aisle. Two intricately carved medieval grave slabs at one time formed a tomb chest and date from the mid-twelfth century. The lid is decorated with the signs of the zodiac, mounted knights and winged beasts. The base of the chest shows a bishop holding a crozier and St George valiantly fighting a larger-than-life dragon. The legend of v George and the dragon being brought to England by crusader knights returning from Turkey.

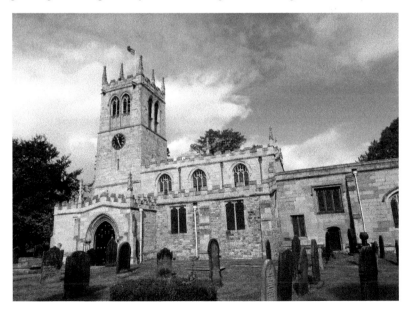

Looking towards the south porch of St Peter's Church, Conisbrough.

Above left: Romano-British carving set into the wall of the south porch.

Above right: South side priest's door.

Other carvings in the church include a Romano-British carving which is set into a niche in the wall of the south porch. Opinions vary as to the subject of the carving, with many believing that it could be the Virgin Mary and the Christ Child whereas others are of the opinion that the carving depicts St Peter holding the keys of Heaven. However, the sculpture is so old and worn that it is difficult to determine exactly what the depiction represents.

There is a piscina and a cross slab in the north aisle, which both date from the thirteenth century.

Dating from the beginning of the fifteenth century, the octagonal carved stone font under the tower features a number of shields and two depictions of Christ, one of Christ sitting in Majesty and the other of Christ rising out of the tomb.

It was then not until 1866 that there was a further restoration of the church, with the north aisle being rebuilt and extended. Many of the church's wall paintings were lost at that time, when the plaster was removed from the walls, revealing the bare stonework. It was also at that time that the vestry was removed and an organ chamber added to the north side of the chancel. The restoration also included building a stone rood screen across the chancel, adding a new stone pulpit and building a new arch to give entry to the base of the tower. The wooden pews, by Robert Thompson – the 'Mouseman of Kilburn' – were added at a later date.

St Peter's had two 'squints', one, known as a 'hagioscope', and the other, from a different age, was known as a 'lychnoscope'. However, the ancient lychnoscope

and its door were removed during the nineteenth-century remodelling. Various theories have been forwarded as to the functionality of the 'squints', the most feasible being that they enabled lepers, or other persons not permitted to enter the church, to receive Communion. It was also thought that the 'squints' could have been used to hear confessions. More often than not the 'squints' enabled those not permitted inside the church to witness the Manifestation of the Host.

Conisbrough hosts the traditional Tittlecock fair every Good Friday. An integral part of the day is the procession, when a large wooden cross is carried to St Peter's and a midday service is held. The origin of the fair dates to the time when, like most other towns in England before the Industrial Revolution, Conisbrough was an agricultural town. Every year on Good Friday, people from outlying districts came to pay their tithe taxes at Tickhill. As so many people were gathered together, it soon became a tradition to hold a fair on that day, the Tickhill fair. One of the main attractions of the fair was the cockfighting events. These were somewhat of a spectacle, and the cock fair at Tickhill became quite famous, so much so that the fair soon became known as Tickhill Cock Fair, which was later corrupted to 'Ticklecock Fair'.

In 1874 the church choir went on strike, and the vicar announced from the pulpit that 'they had lost their senses'. The vicar later withdrew his remarks and expressed his sorrow for making the statement in the first place. The choir resumed their duties, on the proviso that there would not be any similar recurrences.

In 1894 Queen Victoria granted 'closed Churchyard' status to St Peter's, which effectively meant that only in exceptional circumstances would future burials be allowed in the churchyard, and, further, that responsibility for the upkeep of the church became the responsibility of the local authority.

In 1912 discussions were held with a view to replacing the church bells. An estimate for the replacement was obtained in December of that year which amounted to £502, and this figure did not include any necessary additional masonry work. Over the following two years various fundraising activities were held and, on 18 August 1914, the eight bells were cast by Taylor's of Loughborough. All eight of the bells were given saints names: Andrew (treble), John, James, Matthew, Mark, Luke, Paul and Peter (tenor). It had been hoped that the bells would be dedicated and rung for the first time on 4 November 1914 but, due to skilled men being away and fighting in the First World War, the ceremony had to be postponed. When the bells had been installed just a few weeks later on 25 November 1914, Canon Henry Edward Nolloth, vicar of Beverley, came to preach and the bells were rung for the first time.

The porch was restored during the early part of the twentieth century and, as a memorial to those who died in the Second World War, the area was refurbished in 1954.

The remains of an ancient preaching cross can be seen in St Peter's churchyard. It is thought that the cross is older than the church itself.

Location: DN12 3HL

About the Author

David Paul was born and brought up in Liverpool. Before entering the teaching profession David served as an apprentice marine engineer with the Pacific Steam Navigation Company.

Since retiring, David has written a number of books on different aspects of the history of Derbyshire, Cheshire, Lancashire, Yorkshire, Shropshire and Liverpool.

Also by David Paul:

Eyam: Plague Village
Anfield Voices
Historic Streets of Liverpool
Illustrated Tales of Cheshire
Illustrated Tales of Yorkshire
Illustrated Tales of Shropshire
Illustrated Tales of Lancashire
Illustrated Tales of Derbyshire
Speke to Me
Around Speke Through Time
Speke History Tour
Woolton Through Time
Woolton History Tour
Churches of Cheshire
Churches of Shropshire
Churches of Lancashire
Churches of Derbyshire